MW00608440

# PRAISE FOR *TRESPASS*

"*Trespass* is a moving, brave, unflinching, and loving light shined on those who live among us in the shadows. Through stunning images and their own words, Kim Watson gifts us with the vastly complicated but also wholly relatable inner lives of some of our most unlucky and invisible neighbors."

—TREY ELLIS, writer and filmmaker

"Through the captivating prose of Kim Watson's masterpiece, the vibrant tapestry of Los Angeles comes alive, revealing the intricate threads that humanize its diverse inhabitants and transform a city of strangers into a chorus of interconnected souls."

—JENNIA FREDRIQUE APONTE, artist and cofounder of Art Melanated

"There is a double meaning in Kim Watson's moving, compassionate, and thoughtful photo narrative, *Trespass: Portraits of Unhoused Life, Love, and Understanding*. The public debate about homelessness portrays unhoused individuals as trespassing on public space and destroying community life. Yet, Watson's personal narrative and moving images demonstrate the transgressive power of befriending people who are suffering through social and material deprivation that few can imagine. Startling images of the hidden humanity and beauty of people who are unhoused are juxtaposed against shots of encampment sweeps, burned-out RVs, limbs extending from tents, or a person hidden beneath blankets, representing the fleeting contact that most of us have with those on society's margins. This contrast is intentional and, along with Watson's deeply felt reflections on his friends and interactions, shows how much more we all might gain from not only seeing but embracing our unhoused neighbors."

—RICKY BLUTHENTHAL, PHD, professor of Population and Public Health Sciences and associate dean for social justice, Keck School of Medicine at the University of Southern California

"Kim Watson's visionary images are augmented by the revealing stories he shares in his fierce book, *Trespass*. His photos and stories have compassion and clarity for the people living on the streets of LA today and encourage us to pause and contemplate."

—BARBARA BESTOR, architect and director of the Julius Shulman Institute of Woodbury University, and founder of THE BAG LA

"Devastatingly beautiful, brutally honest, a soul-stirring journey." —SALIM AKIL, writer, director, and producer

"*Trespass* redirects our gaze, our hearts, our minds to better see each other and to see ourselves. By example, Kim Watson reveals a pathway back to our own humanity by introducing us to just some of the many people he has come to call friends. This poetic journey from the depths of isolation to the heights of unconditional love is a majestic expression of how one individual can make a difference."

—SHERRY SIMPSON DEAN, senior director of engagement and impact, Independent Television Service (ITVS), Emmy-winning film producer, and author of *Fluent: Mastering Human Fluency in the Age of Artificial Intelligence*

"An intimate portrait of humanity in the rubble of a society in decline." —ARIA DEAN, artist and writer

"Through poignant narratives and evocative visuals, Watson unravels the complex lives, struggles, and resilience of individuals within the homeless community. The vivid imagery lays bare the day-to-day challenges, emphasizing the need for compassion and understanding rather than judgment."

—SOL APONTE, cofounder of Art Melanated

"In *Trespass*, Kim Watson masterfully shows us a world many choose to turn a blind eye to: people experiencing homelessness. Kim isn't running around Los Angeles photographing people during one of the worst moments of their lives to exploit them. He connects, gets people to open up, and reveals the web of emotions, struggles, and triumphs of people who call the street, tents, or RVs home. Through his lens, Kim offers a wake-up call. The faces and stories in this book are just like ours. They're full of dreams, dreams deferred, and hiccups. But also faces and stories of resilience. You'll find yourself deeply moved, informed, and equipped with a sense of urgency to act on behalf of our unhoused neighbors. You'll see them for who they truly are—our brothers, sisters, and friends."

— ETHAN WARD, award-winning journalist who once called his car "home" for a year

# TRESPASS

### Portraits of Unhoused Life, Love, and Understanding

## KIM WATSON

Broadleaf Books
Minneapolis

Library of Congress Cataloging-in-Publication Data

Names: Watson, Kim (Artist), author.
Title: Trespass : portraits of unhoused life, love, and understanding / by Kim Watson.
Description: Minneapolis : Broadleaf Books, [2024] | Includes bibliographical references.
Identifiers: LCCN 2023032506 (print) | LCCN 2023032507 (ebook) |
ISBN  9781506491134 (hardback) | ISBN 9781506491141 (ebook)
Subjects: LCSH: Homelessness—California—Los Angeles. | Homeless persons—California—Los Angeles.
Classification: LCC HV4506.L67 W47 2024  (print) | LCC HV4506.L67  (ebook) | DDC
    362.5/920979494--dc23/eng/20231031
LC record available at https://lccn.loc.gov/2023032506
LC ebook record available at https://lccn.loc.gov/2023032507

Cover design: Yolanda Cuomo
B&W correction by Von Thomas Editions

Print ISBN: 978-1-5064-9113-4
eBook ISBN: 978-1-5064-9114-1

Printed in China.

# CONTENTS

Foreword                                    1

Introduction                                5

ELIZABETH                                   7

AL                                         17

KIM                                        23

JIMMY                                      27

CRYSTAL                                    37

DADISI                                     49

LORI                                       55

DON                                        57

LEE ANNA                                   60

CARLOS                                     68

ALAESHA                                    70

MEMORIES                                   74

SASHA                                      81

JUICY                                      88

GARDNER                                    92

FAMILY                                    105

CHADWICK                                  111

SHORTY                                    115

IN PLAIN SIGHT                            117

MARIA                                     122

FELIX                                     130

FELIPE                                    137

FELICIA AND LEON                          141

DEATH                                     150

WACO                                      155

GRACE OF GOD                              159

THEM FACES                                160

AUNTIE                                    165

MICHELE AND RAY-RAY                       169

BRANDON                                   180

BOBBY                                     186

SURRENDER                                 191

BRENDA                                    195

HEROES                                    200

A PIPELINE TO
   THE STREET                             204

THERE IS STRENGTH
   IN THE HUMAN SPIRIT                    205

Acknowledgments                           207

About the Author                          209

LA County Facts at a Glance               211

Notes                                     216

# FOREWORD

A burst of sunshine was thwarting the typical chill of a New York winter at Christmas, and the cold winds off the Hudson River had taken a brief sabbatical that made the walk between the housing projects and the recently erected West Side high-rises almost tolerable. I was in the moment, absorbed and content with holding Jenifer's hand, enjoying our holiday return to my hometown.

I left in 1991, on the heels of the 1989 murder of Yusef Hawkins by a racially motivated mob in Bensonhurst and headlines proclaiming five Black and Latino young men guilty of a vicious rape they did not commit. The 1980s were both a time of excitement and what some have described as the city's darkest decade. While art, club life, punk, and the emergence of hip-hop pumped energy into New York's street scene, the '80s also saw the first cases of AIDS, the appearance of crack, increases in poverty and crime, and revelations of rampant police brutality and corruption.

But that was then! Now, I was merely taking a walk with my wife, nothing on my mind except the holidays and everyone assembled around a table stacked with turkey and gravy, collard greens, macaroni and cheese, and pie—lip-smacking favorites.

Ahead of us, a man reached down and into the depths of a garbage can, which was not unusual. I was used to seeing homeless men and women traversing the streets, languishing in the subways, and slumbering in the city's parks. I knew many by name, speaking to them and handing over a dollar as I passed. But this, well, this was 64th Street and Amsterdam Avenue, and we were standing in the opulent, well-financed glow of Lincoln Center, Juilliard, and the Met. This was not a neighborhood whose residents tolerated the visitations of the homeless.

I could not see the man's face as he pulled out remnants of half-eaten sandwiches and scraps. He was in his own world, and I was in mine . . . until I glanced his way again. Then I froze.

Jenifer looked at me, puzzled, with one eyebrow raised, waiting for me to take my next step forward. But I did not move. Instead, overcome with a heaviness I didn't understand, I stood speechless. I could not put words to what was going on inside my head—perhaps inside my heart as well.

"It's Jamie," I whispered.

"Huh?" she asked as I stood immobilized, eyes fixed on the figure before me. The stranger had not revealed his face, but I knew. He dug deeper, then pulled a newspaper from the can's depths and tucked it away.

"It's Jamie!" I repeated softly but now with more confidence. It was weird and instantly devastating. Then he stood straight up, exposing a profile I knew all too well. I was right.

It was my old friend. Cub Scouts, church, hanging out at high school basketball games, suite-mates in college, concerts in the city—and then, without explanation, Jamie started to grow distant. But I had been focused on my own transition from campus life to my first apartment in Fort Greene, Brooklyn.

Eventually, I knew something was wrong when his girlfriend pulled me aside to tell me he was "acting strange." At twenty-one years old, I'd barely ever heard the words "mental illness," much less seen anyone losing themselves to the voices in their head. Suddenly I was watching something unfold that I could not make sense of.

New York's homeless "problem" had been brewing for years, not to mention the hundreds of families moving into shelters nightly. In fact, at this moment, as Jenifer and I visited New York, politicians and advocates were battling over solutions to the record-breaking numbers of homeless on the city's streets. Now, years out of college and long after we'd lost touch, Jamie stood fifty feet away from me, and I couldn't stop the tears. Jenifer moved closer, snaking her arm through mine reassuringly. I could feel her eyes on me, watching me intently, but I could not return her gaze.

Layers of dirt had turned his long winter coat and pants into stiff, shiny armor. His unwashed face, typically light-complexioned, was as dark as coffee. His lips were moving, but no one was listening. I didn't move. I didn't call his name. I didn't help. I did nothing. I watched Jamie turn and walk away on feet that clearly hurt. And then he was gone. I turned a blind eye to someone in need, a friend. And though that guilt may have softened with time, it has never left me.

I have often thought of Jamie and my awful response. How could I not have stepped forward and embraced him? I knew I was not a callous and uncaring man, but I am still haunted and embarrassed by my reaction. The years since have not lessened my disappointment in myself, but they have led me to try to do better. On the path to understanding, I realized that it wasn't a lack of empathy that struck me silent; instead, it was fear. Fear of the unknown. Fear that if someone close to me could fall that far from grace, perhaps I could too. I had let my fear overpower me—but that would be the last time I allowed it to interfere with my instinct to help.

*Trespass* is my humble attempt to shine a light on one of the biggest travesties of our time: homelessness. I have spent over four years photographing and telling the stories of people in Los Angeles like Jamie because they are literally our friends, neighbors, and family. Their stories shed light on the complex situations that lead to homelessness, the individuals who struggle to rise out of it, and those who have resigned themselves to it. Only when we dispel the myths and change the "them" to "us" will we acknowledge our shared humanity and unite to make a difference in the lives of those who need us. For they, too, have a contribution to make to our society.

These pages are filled with their experiences and thoughts. They are the heroes in this book—flawed, courageous, addicted, talented, irrepressible, funny, and even frightening at times. Yes, they are just like you and me. They are human.

My deepest thanks to my unhoused friends and acquaintances who have welcomed me into their lives and allowed me to tell their stories. The lessons they've taught me will never be forgotten. I also thank the dedicated professionals and scholars who have shared their research and insights with me. They remain a sounding board, ensuring that my facts are correct and that my conclusions are grounded in truth. These individuals and institutions work relentlessly to find solutions, often without recognition, and I am grateful for their support and friendship.

Sadly, over the years, I have encountered other friends who are homeless for myriad reasons: drugs, divorce, physical or mental illness, or a lost job . . . but my response is different, and for that I am indebted to Jamie. I dedicate this book to him as we replace complacency with action, disdain with understanding, and fear with love.

# INTRODUCTION

For over four years, I have traveled the streets of Los Angeles, from Venice and Santa Monica to China Town, Skid Row, and beyond, interviewing and photographing hundreds of homeless. Some I knew long before I started photographing. They were strangers who became friends as my family and I drove around delivering food out of the back of our car. They welcomed me into their lives with open hearts and transparency, and I have come to know them intimately, sitting outside tents; listening to stories of their successes and failures; families and loves lost and found. With no fear of judgment, our relationships have grown deep, solidified by the mutual trust and affection we share.

Others were merely passing, giving me just enough time for a brief chat and a photo. But even the briefest of encounters provided lessons I'd never forget.

I have experienced the loss of a friend whose RV was ablaze when I arrived for a visit. I have felt delight when someone finally received housing and medical services after years sleeping in a threadbare tent while suffering from arthritis. I've watched with despair as police laid a white sheet over a homeless victim of an overdose, and I have had interviews end abruptly when someone left to turn a trick for some quick cash.

Their stories are often tragic, but they are also stories of strength, survival, and resilience. All reveal the price we as a society pay when we are complacent. It is hard to look into the eyes of someone living in the most dire of circumstances, but look we must, if we are to understand and care for those most in need of our help.

The people profiled in these pages gave me permission to photograph them and tell their stories. They want to be seen and heard. This was a gift they gave to me, and *Trespass* is my opportunity to share that gift with you.

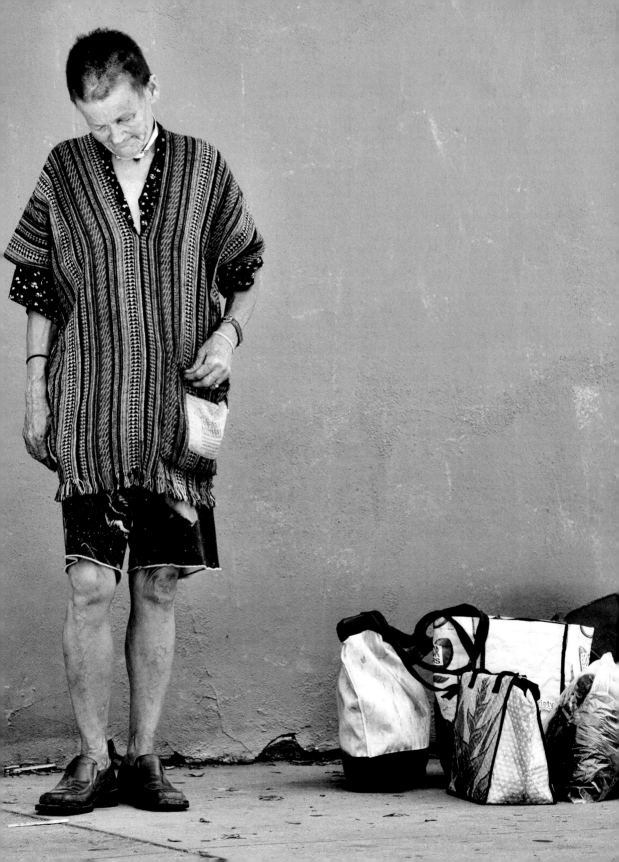

# ELIZABETH

I met Elizabeth a few months earlier, Easter morning to be exact, and we talked with no regard for time as church bells rang in the distance. I had been hoping to find her again, a long shot, until it wasn't. I spotted her as she rose from a bus stop bench and started walking, arms filled with her belongings and unaware she was being watched. She moved down the street as I hurried from my car and ran to catch her, calling her name.

She stopped, turned, and smiled sweetly, openly. I wasn't sure if she remembered me or just welcomed the company, but she showed no fear. And we caught up.

Sitting across from each other in the middle of the sidewalk, I remembered how she loved jewelry and clothes. Her bags were filled with outfits; her style was her own and intentional. I commented on the brightness of her crystal blue eyes, and she beamed proudly. I asked to take her picture, as I had before. She nodded and stood, lost in her own world as I circled her—click-click-clicking away. Without calculation, her every motion expressed an emotion or moment she was reliving in real time. I was witnessing her truth. Then, after good-byes, I walked away.

"Hey," she called after me, pulling a small, framed painting from a shopping bag. It was a painting of a young woman with bright blue eyes, just like hers. I don't know where she got it or how long she had it, but it was precious to her, I could tell. She held it out to me, offering me her treasure to remember her by. But I couldn't take it; it was too dear to her, and now she was too dear to me.

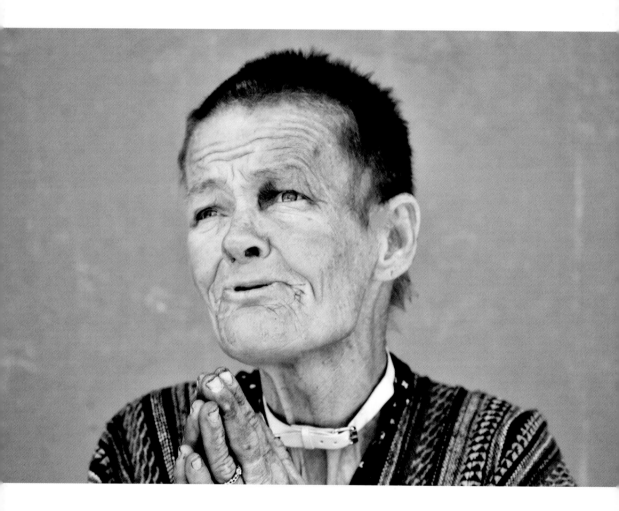

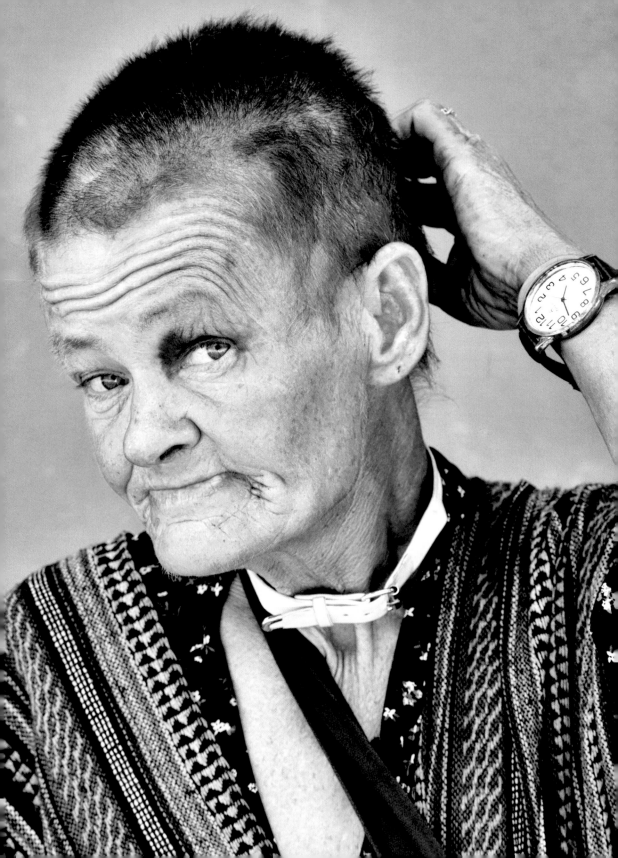

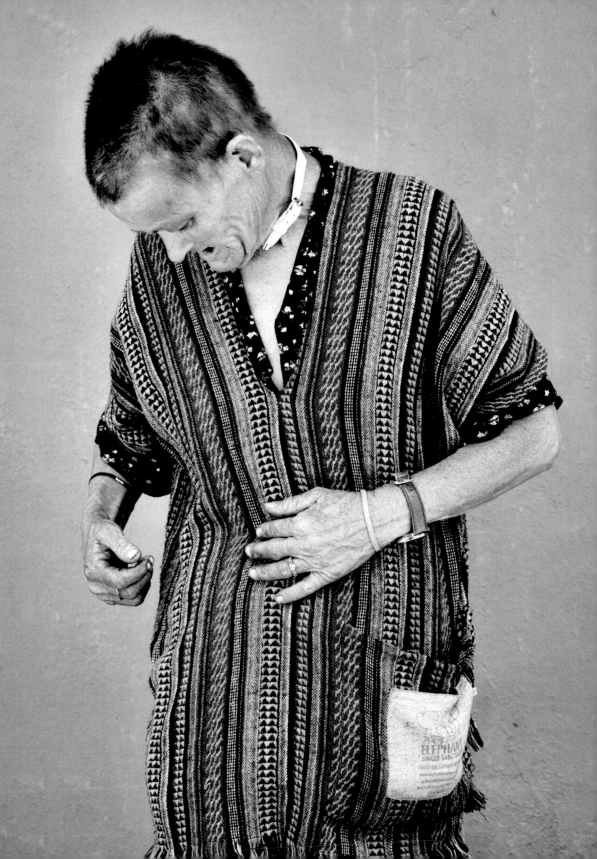

She sat on a bench at 7th and Main,

her blue eyes glued to nothing in particular

The occasional boom of the Fourth of July did not disturb—

nor did it interest her

The day was as any other. What's the bother, anyway?

Today or tomorrow, tell me, what's the difference . . .

ain't they all the same?

With nowhere to go, she'll stay right here.

No need to wander far

Home is where you lay your head—

be it tent or be it car.

She smiled when I reintroduced myself—

then I did it again just for good measure

I held out my hand—she put hers in mine

I nodded politely—"My pleasure"

The girl from Tulsa—a Central High School grad

That's miles and years away from here—

Who would know her?

Back home, would they remember her name?

Elizabeth Elizabeth Elizabeth

I said it once, now I'll say it again . . .

Elizabeth Elizabeth Elizabeth

Ain't this a goddamn shame

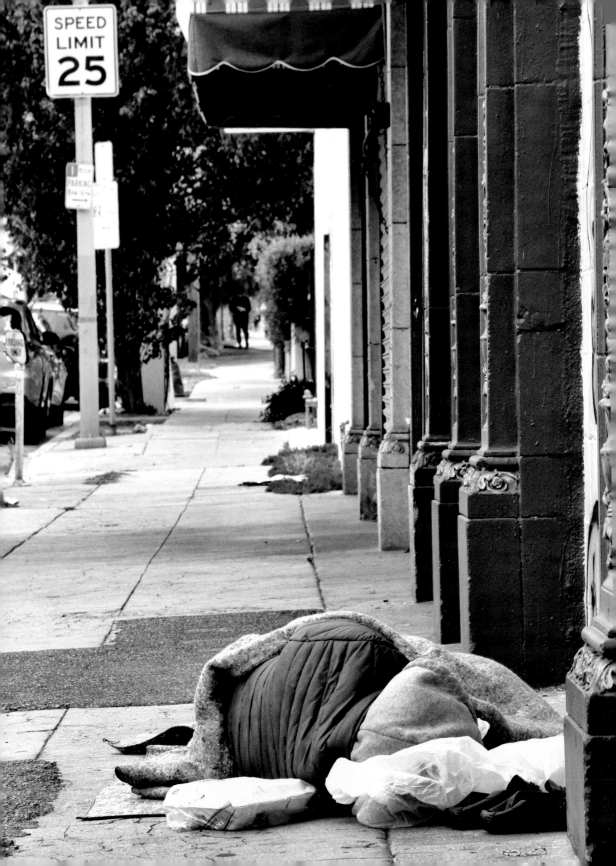

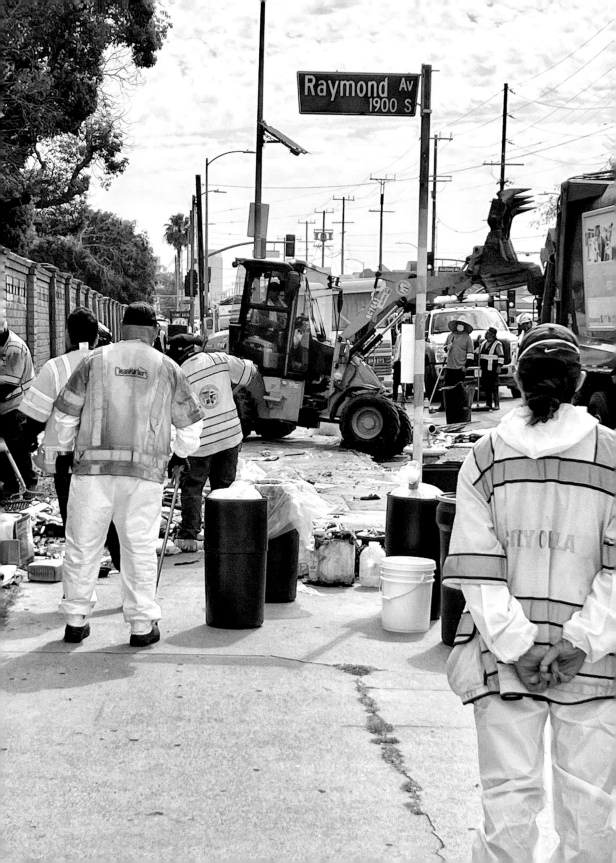

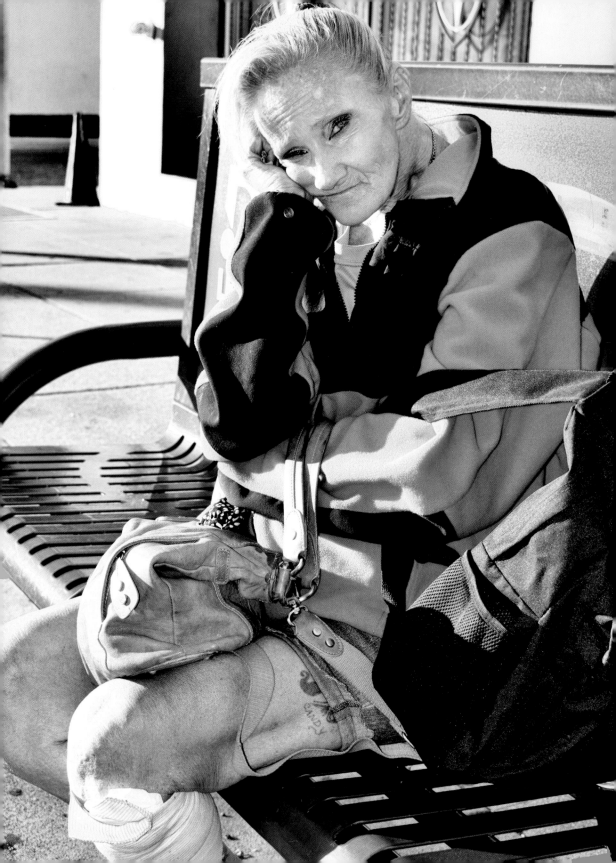

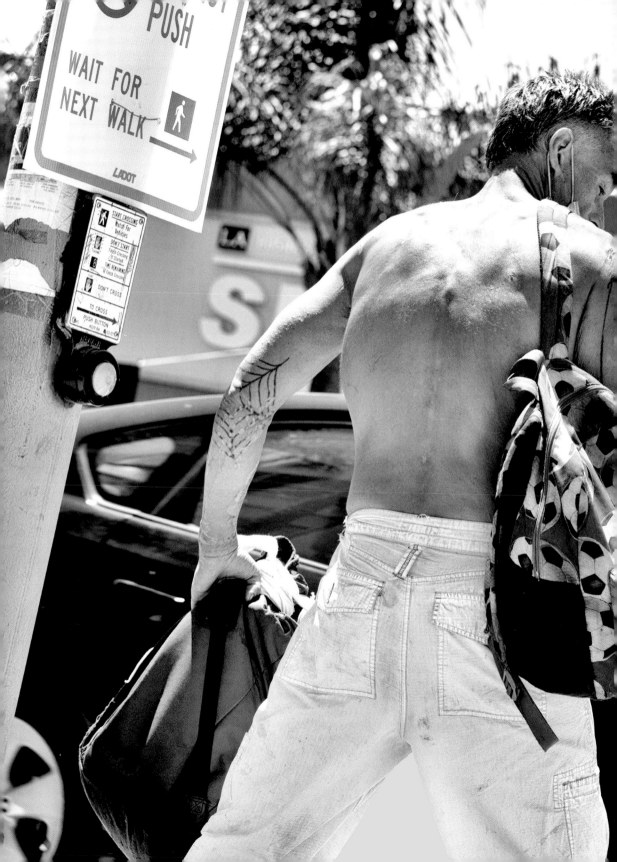

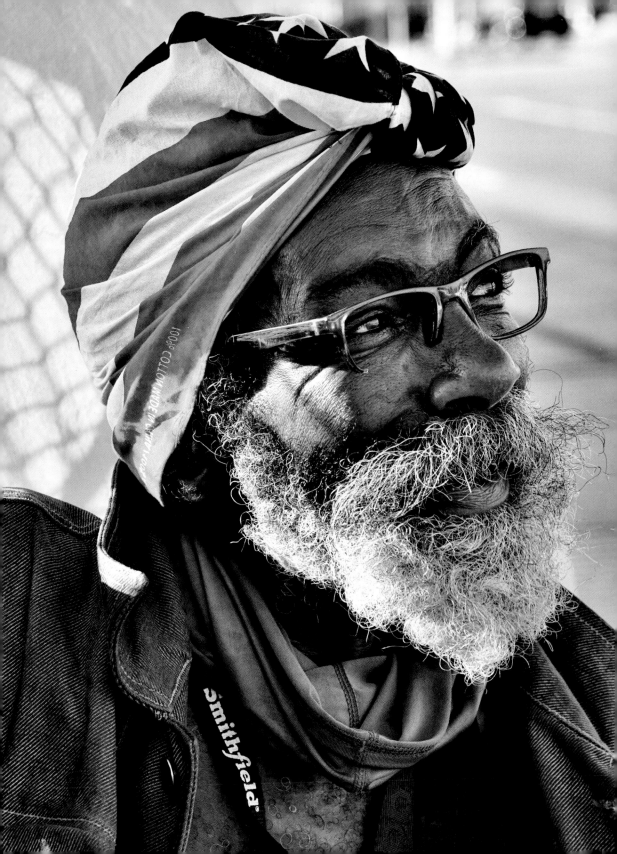

# AL

Al is my friend. From the moment we met, there was something undeniably special about him. Gentle . . . that's it! There's tenderness in his eyes, his easy smile, and his deep-throated laugh.

"I like a beer now and then," he told me with that sly grin of his. Al now has a small room, not far away, and I recall his pride when, after some time of knowing each other, he told me.

"I got my own place," he said, winking at me. Sitting there at the red light and ignoring the cars lining up behind me, I was bathed in his pride. He shared his joy so freely, so beautifully, that I felt his small room was MY small room. It was a victory, and I was happy he chose to share it with me.

But a "room" does not change the reality that Al still panhandles for change, and being homeless is a permanent part of how he sees himself. He often spends nights in the roadside tent, which he playfully calls "my office," socializing with tented neighbors and longtime friends. The years and memories remain fresh and are the price he pays for his time on the street.

On difficult days, I see his smile replaced by disappointment and even pain as he walks on bent legs with the aid of a cane or wheelchair. The car that slammed into him left a limp and open wounds for all to see.

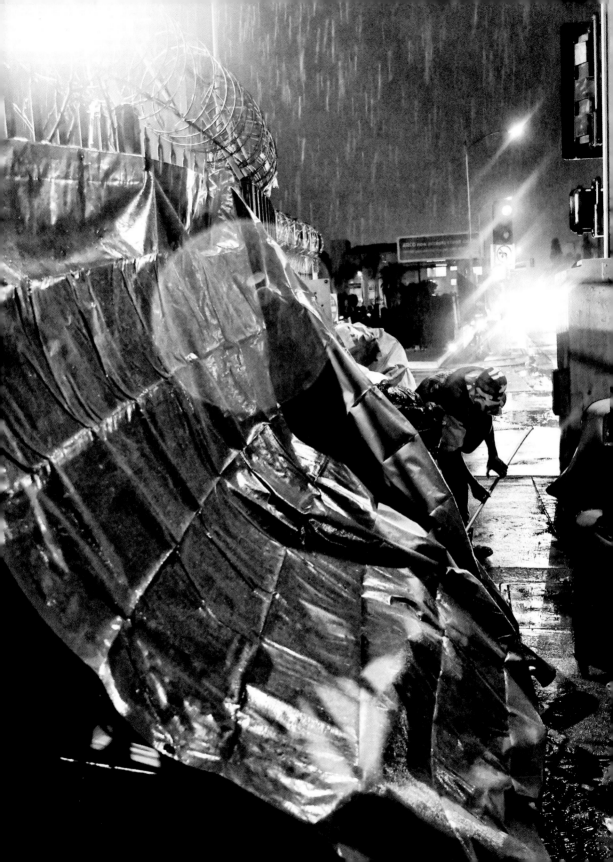

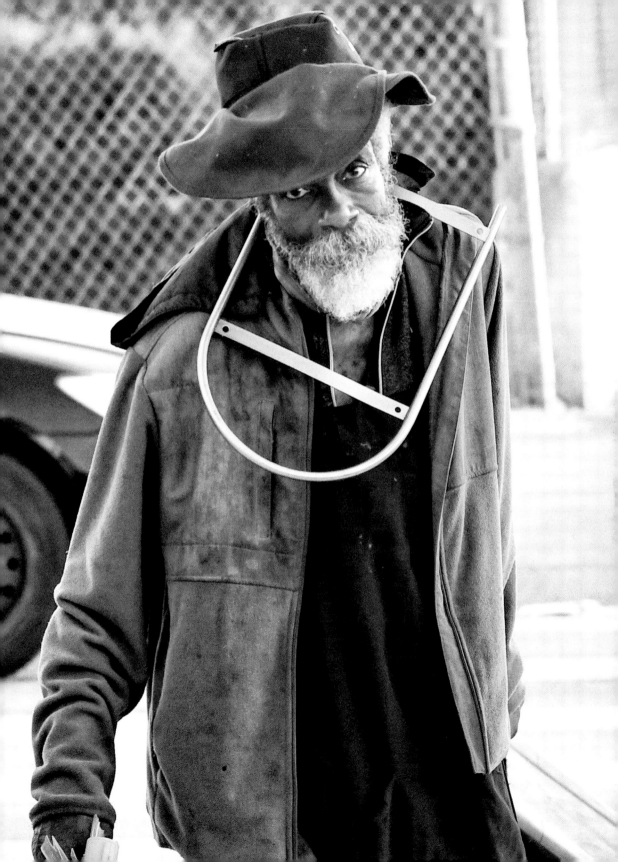

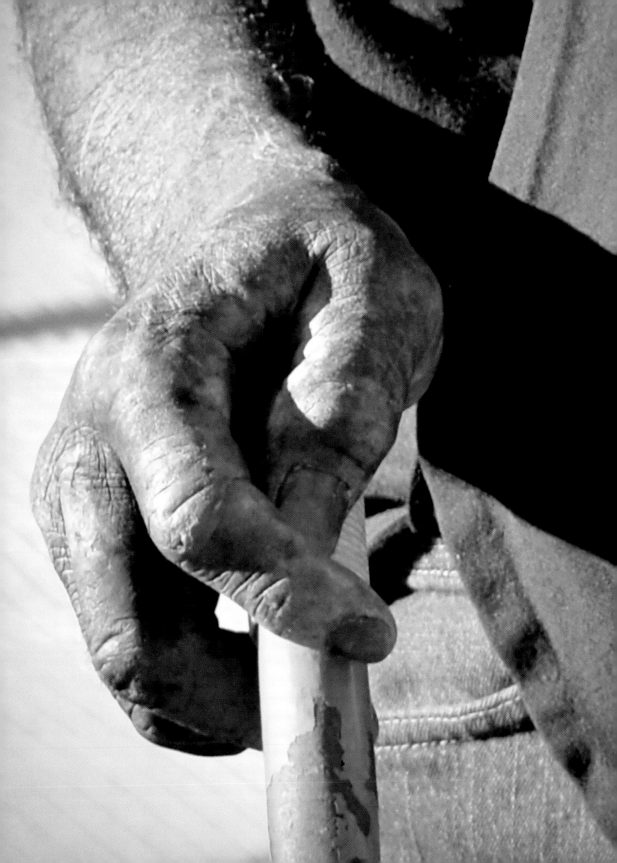

One sunny day not long ago, with cars off-ramping around us, the smile was missing, and the glimmer in his eyes had dulled.

"You OK?" I asked. He was distracted and distant.

"Yeah, fine," he insisted. But that was a lie, and we both knew it. He was in no hurry to speak, and then my eyes followed his to the apartment building across the street. "I been here before that was built," he said.

"How long is that?" I asked.

"Ten years," he answered. His eyes were cast down now.

My gaze fell to his hands. Scarred, scraped, and gnarled, his hands said everything his words did not. A year on the street is a lifetime, and ten years is an eternity that never leaves you.

That day, we parted with our usual farewell. "I love you man," I said.

His smile reappeared, and his eyes brightened. "I love you too."

Al is my friend and I'm better for it.

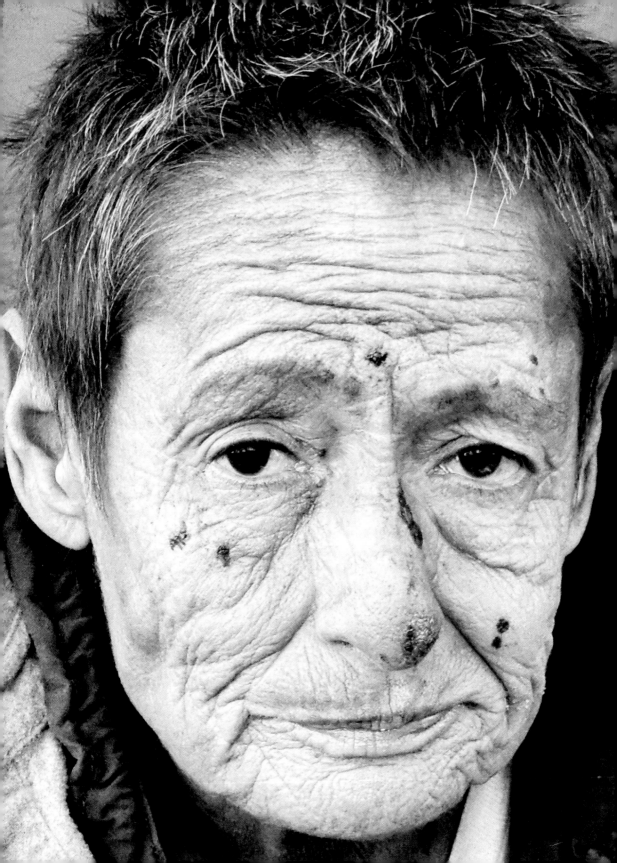

# KIM

## I AM BROKEN

I am broken

    Constantly on the verge of tears brought on by the despair that penetrates like shrapnel, slicing me open and infecting me with rage until I feel like I'm going to explode.

I am broken

    Damaged by the elders I see picking through garbage and begging for pennies. The unwashed young men and women talking to someone when no one's there. The lonely and forgotten who, on this Christmas Day, remember a past that once held the promise of a youngster's dreams. And did I tell you.

I am broken

    Well know this: I may be broken, but I damn sure ain't beaten.

It was morning, December 19, and a pile of dirty blankets covered her small body. Between the deep crevices of her face were the scratches, bumps, and bruises that told her story. Staring into each other's eyes, we talked until we ran out of words. Then I rose from the sidewalk, sat in my car, and wept as I wrote "I AM BROKEN."

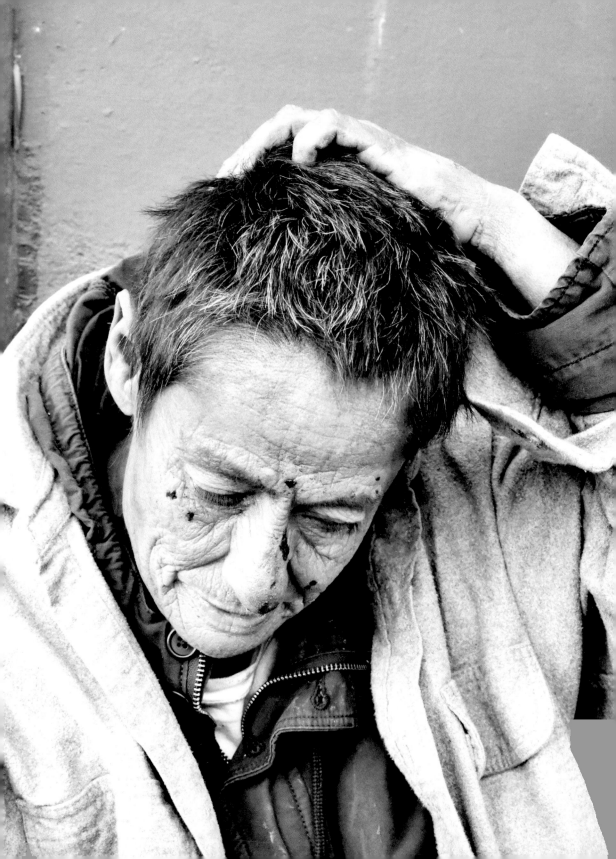

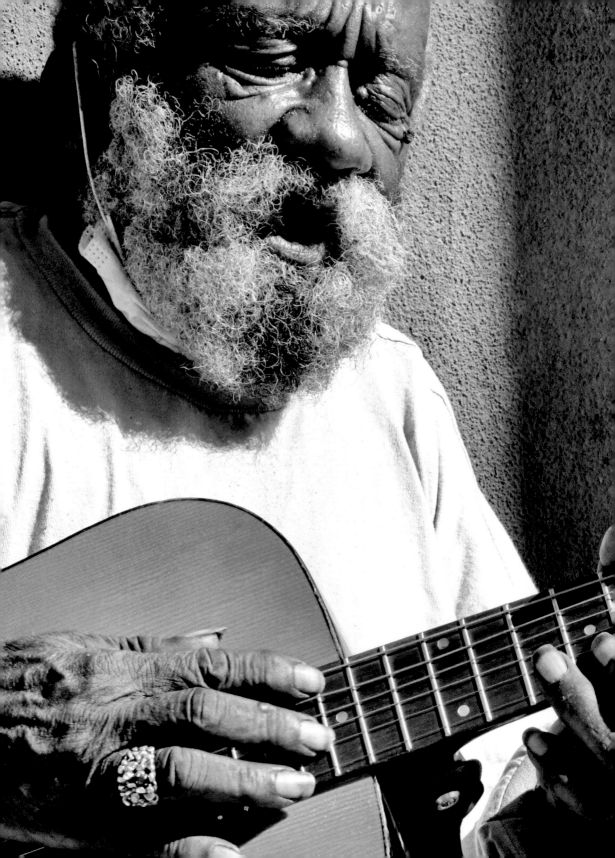

# JIMMY

I sat at his feet, listening as his fingers touched the guitar's untuned strings. It was clear he was no guitar player, but his gentle voice rose just above a whisper and touched me. With eyes closed, his words danced gently upon a melody only he knew.

You see, Jimmy was tethered to another time, yet retained a certain "cool" and hipness, his sentences laced with words from his heyday, when life was exciting and filled with promise.

He spoke of late-night studio sessions and of celebrating Huey Newton's PhD in a room filled with beautiful Black folks. And there was the Thanksgiving Eve dinner with Richie Havens in Greenwich Village.

It's easy to dismiss those whom we don't understand, but Jimmy sang his song softly and made a believer of me.

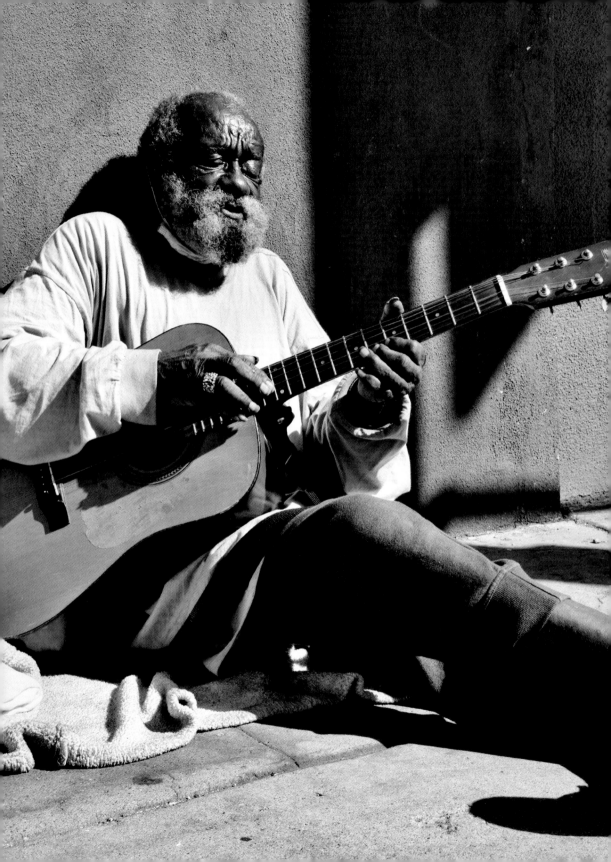

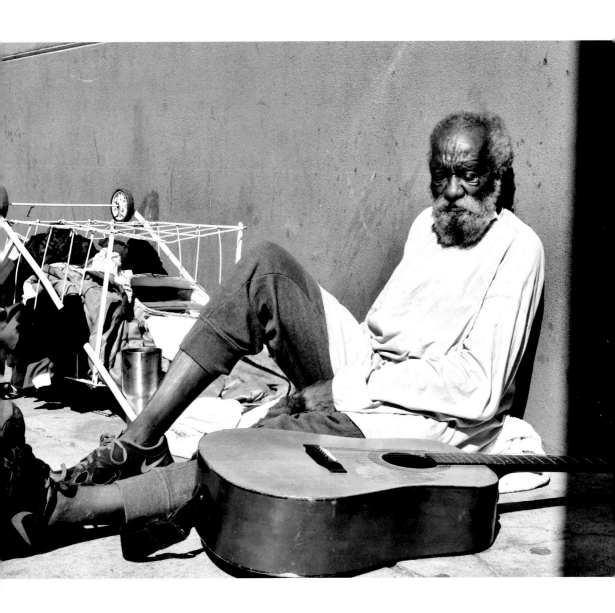

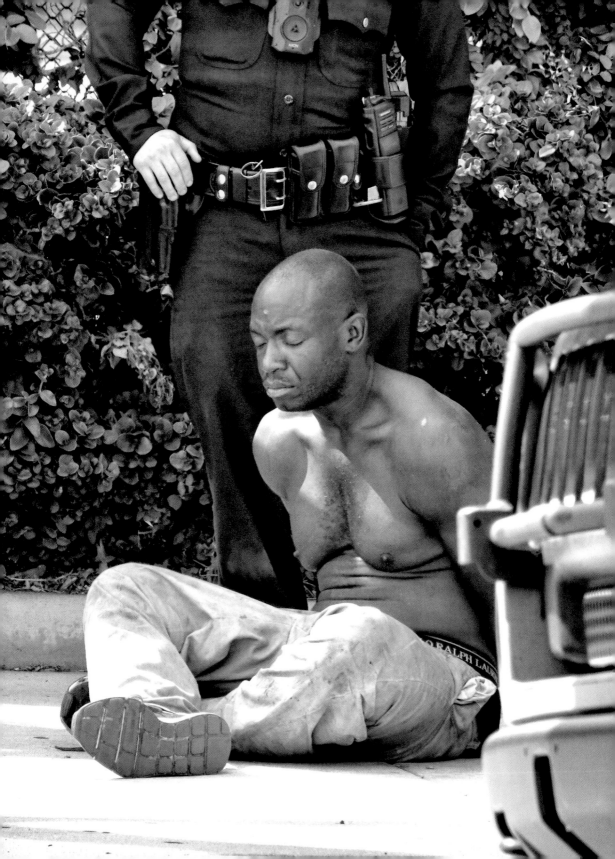

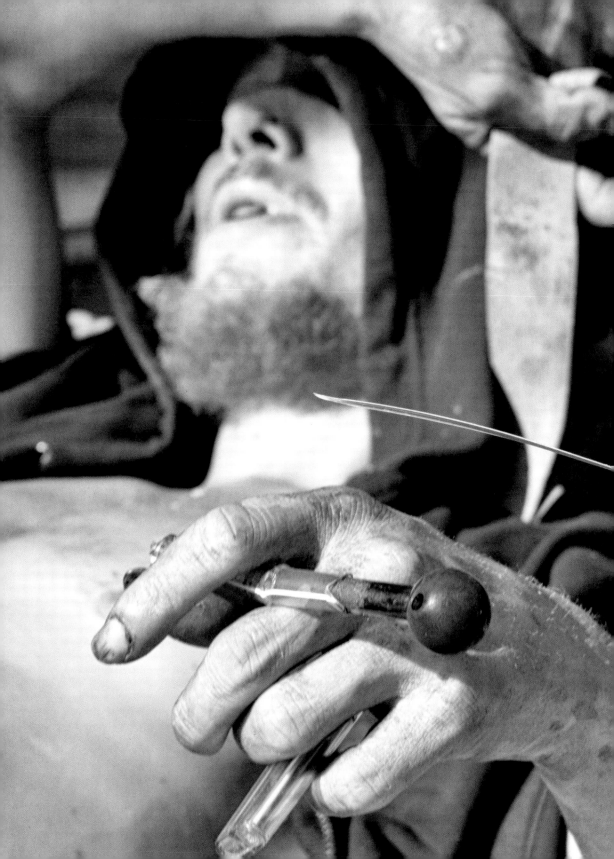

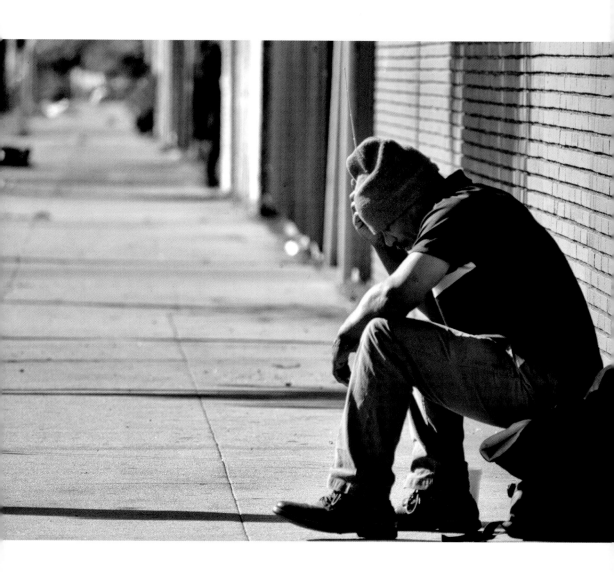

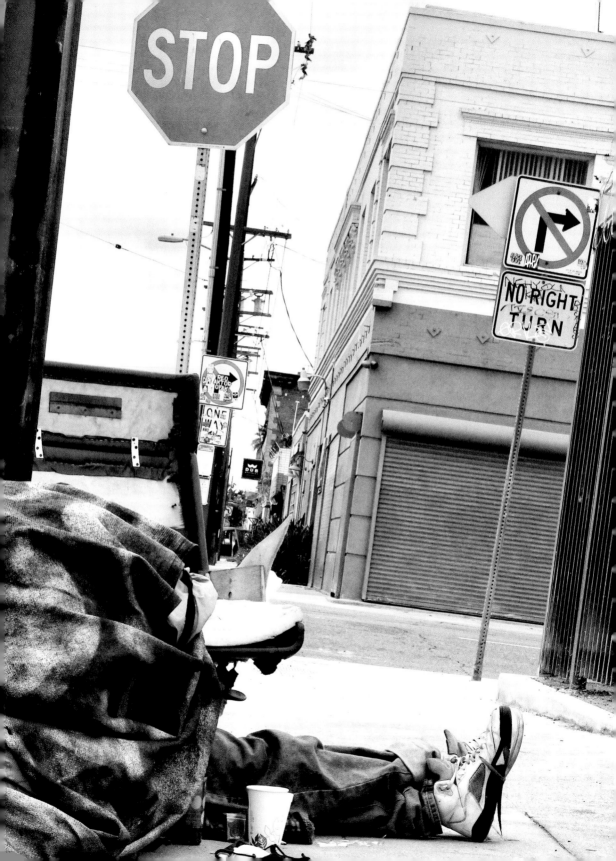

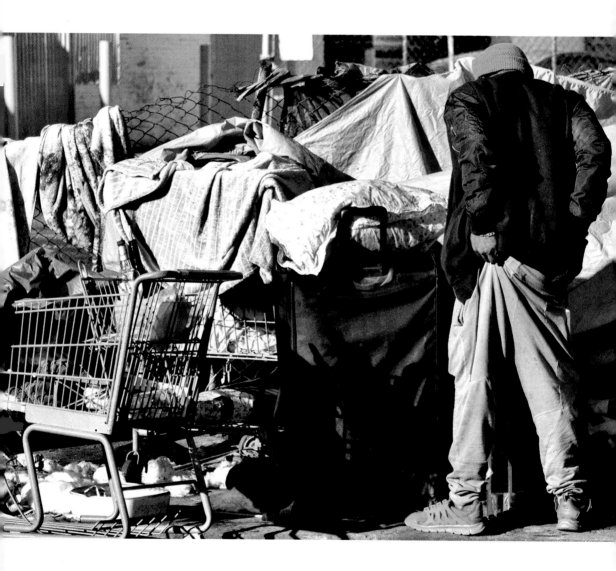

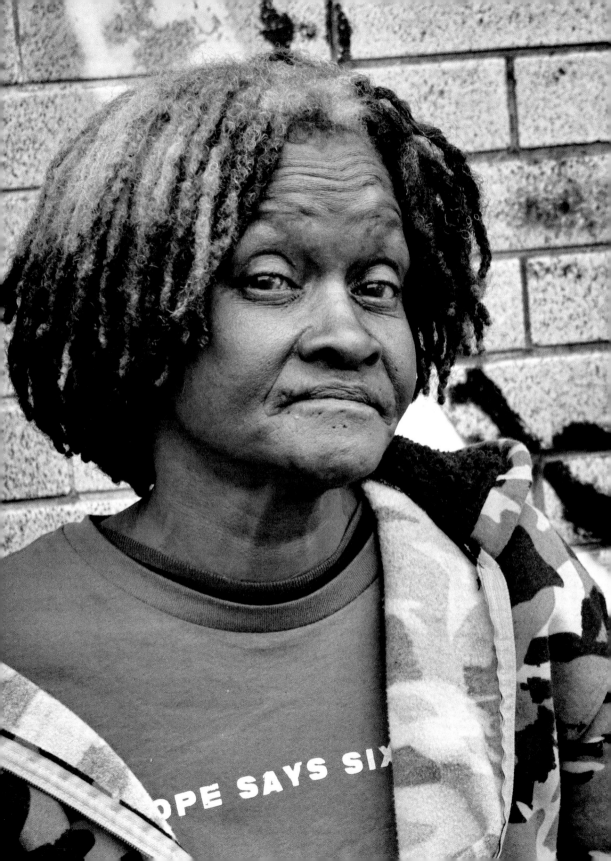

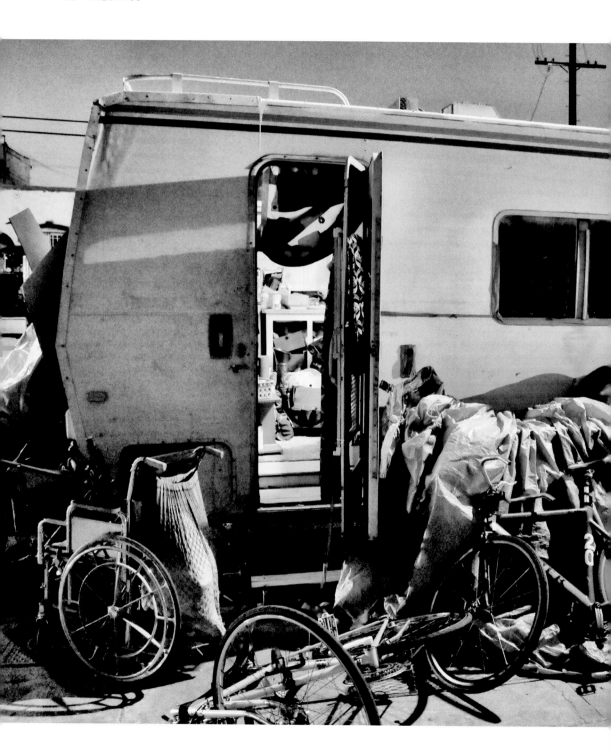

# CRYSTAL

I spent the night cruising, dropping off food to the people on the street between our house and downtown LA. The sun had set, the streets were dark. My wife, Jenifer, was driving and steered us toward home. Only three plates remained on the seat behind me.

Rolling slowly up Washington Boulevard, I wondered if she should stay home when I took these nighttime rides. I never feared for my own safety, my New York roots wouldn't let me, but I wasn't comfortable taking her to some of the locations that I frequented. Of course, she objected to this notion. She's "ride or die," and I love her for it.

We delivered two plates to a familiar tent and drove on as I stared out the open window.

"Pull over here, honey," I said.

I was anxious to deliver the final plate and happy to spot a possible recipient. Jen whipped to the curb, parking beside the old cemetery gates we passed daily.

Stepping from the car, I surveyed several darkened RVs. Stopping at the first one, I called in my toughest New York baritone, "Hey . . . anybody home? Got some dinner here if you want it." No answer.

I moved down the line, one by one, announcing myself and looking for any sign of life inside the other RVs . . . nothing. Finally, I spotted a light ahead, seeping through a cracked RV door. There was a blue tarp draped across the front window, and as I got closer, I eyed the water bottles; wheelchair; bikes; and long, covered table positioned alongside the RV. Relieved at the prospect of delivering the last meal, I moved closer.

A makeshift lock, one of those bungee cords you get at the Dollar Store, held the broken screen door in place—just enough to keep the wind or an intruder from getting in, *if* they weren't too determined.

I approached carefully. Peering through the opening, I spotted a woman inside. She was short and round, and I was now close enough to see the thin, clear, plastic tube that ran from her nose, around her ears, and down to a small oxygen tank resting at her side.

I noticed the festive red pattern of her housecoat and thought she may have worn it to a party in happier times. There was no party tonight, and the times were anything but happy. I was an unfamiliar man approaching a woman sitting alone in an RV on a darkened street. The last thing I wanted to do was frighten her. I stepped forward.

"Excuse me. Excuse me, I have dinner if you want it," I said gingerly. I could see her moving about cautiously, as if each step required some thought.

She turned, surprised by the voice cutting through the quiet of her home on wheels. I leaned my face closer so she could see me more clearly in the dim light. She stared intently, without fear or suspicion. It hurt to see someone so vulnerable, living alone in an RV alongside a cemetery.

"My name is Kim. I have a spaghetti and salad dinner if you want," I said, offering up the dish for her to see.

She smiled and delivered a weak "Yes. Thank you." Her breathing was heavy and labored, and she sucked in hard with every breath.

"Don't move. I'll slide it through here," I said as I approached the screen door's opening. She moved toward me, shuffling on unsteady legs and with great effort.

She extended her hand, and I slipped the plate sideways through the crack.

"Thank you. Oh . . . Thank you," she said softly. She caught her breath as she took the plate from my hand. We could see each other clearly now.

"God bless you," she said. "Thank you."

"You're welcome," I replied. "What's your name?

"Crystal," she answered.

"I'll be back, Crystal . . . I'll be back," I said. We smiled at each other, connecting for a moment. I wanted her to know I meant it.

I walked to the car, repeating Crystal's name several times so I wouldn't forget, writing my notes as Jenifer drove us home.

I returned two days later and stood at the door.

"Crystal, it's Kim," I called out several times before hearing a tired, raspy voice respond.

She called me inside, but I could not see her. I unlatched the bungee cord, unsure of what I would find. I'd never been inside the RV of someone unhoused. Hell, I didn't remember being in an RV—ever! I was used to meeting people in the open, masked and sometimes unmasked but able to safely distance. This was, after all, the first year of COVID-19. A year of political uncertainty and madness.

But I walked up the broken steps and into Crystal's world. It was no rose garden, but it did not smell as I thought it might. It was dark and cramped, yet relatively organized considering that a lifetime was jammed inside. I imagined this RV, in better days and with its original owner, providing a home away from home for family trips filled with laughter as they traveled up and down country roads, headed for distant towns and adventures.

Crystal was lying in bed to my right, drawing in air as best she could through the tube in her nose. COPD kept her breathless. Her cheeks were round and red, her eyes set at half-mast. She was a straight-up OG with a big heart.

Crystal had been in the emergency room the night before, and someone took the opportunity to enter the RV and steal the tools, which she used to make repairs. Now, sick or not, she was pissed off and wanted to "kick their ass."

We looked at each other through the shadows and took each other in, trying to understand what circumstances led to this place and time. We were surrounded by machines, medicines, and mementos, like the odd little porcelain shoes she loved—"*antiques*," she insisted as she proudly pointed them out, strategically placed where she could easily see and enjoy them from her bed.

A large oxygen tank was at her side; another smaller tank and a portable unit were nearby as well. A computer monitor was hooked up to a laptop, serving as a television and powered by the electrical cord running out the window and hitched to the light pole outside. A fridge sat under a rear window, and broken cabinets hung above. There were homemade shelves and cubbies. A closet held her clothes, including a prized Oakland Raiders jacket; another cabinet

contained bottled water and cereal; and a small bowl on the floor was filled with food for her beloved cat, Poppy.

We shared stories, cutting through bullshit as we opened ourselves up to each other. I knew the hard exterior I was facing was like most others I'd known . . . simply hiding the hurt and trauma of life, unvarnished and raw.

And after a time, we said our goodbyes.

"Do you need anything?" I asked, expecting a request for water or more home cooking. She propped herself up on her bed and looked me in the eye with a directness I didn't expect.

"A friend!" she answered.

We spent the next several months getting to know each other as I stopped by once, twice, three times a week to chat. I told Crystal when I was going away for vacation with Jenifer and Hunter, our son. She told me when she was working on new cabinets with her newly purchased toolkit of drills, hammers, and everything a carpenter would need for a day's work. She had a cadre of underlings who she bossed around, and I chided her to "be nice." She'd ignore me, then smile as she gave it a try, until next time. I can't explain why, but we threw away all pretense.

Crystal loved salads and the collectable tchotchkes stashed around the RV. I loved her grit. A match made in heaven, I suppose.

Crystal became homeless years ago when the house her family rented was sold from under them. Her mother and brothers found other quarters, while she landed in a tent at the end of a cul-de-sac near USC. She didn't say much about her family, and I didn't pry too deeply. Still, she spoke honestly about her broken heart and poor judgment in men, the eight children she felt ill-equipped to love, doing prison time on a gun charge for a man who wouldn't or couldn't love her, and a life of unfulfilled dreams. Her hustler's instincts enabled her to survive, but she was tired, exhausted from the fight.

It was June. Crystal sat in the wheelchair she used when she was outside the RV. She had confronted a "grown-ass" possum and its two babies, who were living in her mattress. She shot an arrow at the mother. Don't ask me where she got a bow and arrow, but I'm sure she would have produced a pistol had she not been afraid the cops would show up. Now the mattress sat outside, and she pointed out the entry and exit holes on its underbelly.

This day, she wanted answers. She looked me in the eye. I didn't know the question yet, but I did know that whatever my answer was, it better be real talk. She hated bullshit.

"Why do you do what you do?" she asked.

The question surprised me. I took my time. She deserved an honest answer. I finally looked down the barrel of her gaze.

"I do it because I grew up with a lot of love, and when I see someone who doesn't have that, someone who needs it . . . well . . ." I ran out of words.

She smiled, allowing herself to go soft for a moment.

"All I ever had was tough love," she said. She paused before continuing, "and abuse."

We talked for a while about all of that.

My heart ached for Crystal. I've heard the stories over and over as I've roamed the streets, seeking my own understanding of how people, good and bad, loved and unloved, end up unhoused. Addiction and mental illness are major contributors and a common denominator for many, regardless of gender, but so is the abuse they received as children. Yet, it's important to remember, parents are only the sum of what has been poured inside of them as well. This is the cycle we contend with, isn't it?

Crystal's brutal honesty about her past, who she was, and what she had done never failed to amaze me. She was tougher than nails, a real boss lady, and I can only imagine the potential she would have fulfilled if the little girl who knew only "tough love and abuse" had been nurtured and supported.

Three weeks later, I rose early and was taking my usual route downtown. I had planned to stop by Crystal's with a bite to eat on my way back. At least that's what I intended . . . until I saw the swirling lights atop the fire trucks. My stomach tightened, and though it was selfish, I prayed it was one of the other RVs in distress. It was not—it was hers. The street was closed, but I slipped through on foot, watching the firefighters circling the still-smoking RV, talking, inspecting.

I was interviewed by the detectives and Arson Unit investigators, sharing the information Crystal had given me when I filled out her request for housing and medical with LAHSA (Los Angeles Homeless Services Authority). Full of attitude and only half-kidding, she had warned me, saying, "Well, they better let me take Poppy or I ain't going nowhere."

We laughed and I told her, "He's one lucky cat, 'cause I'd leave his ass," which horrified her but made her laugh even harder.

But waiting for services is no laughing matter. With every visit, I asked if a caseworker had stopped by yet. The answer was always, "No." I was always embarrassed by LAHSA's and my own failure. They finally responded with a letter: "Thanks for your concern," and nothing more.

Now I stood watching alongside the bodega owner who would bring her water; the friends who took her mail at their house and checked on her regularly; and others who, like myself, saw her strengths and vulnerabilities as just part of a package that is the human condition. We forgive celebrities every day as they abuse lovers, succumb to mental illness and drug addiction, and struggle to find their way in a complex world. So why can we not find it within ourselves to look with compassion and empathy at our neighbors living in the shadows?

Are they less deserving of our love?

Did she do drugs? Probably. Did she sell drugs? Maybe.

Did she leave her children behind because she felt unable to properly love them? Definitely. But if you think that's the life Crystal wanted, you're a fool. And if we think, collectively, that we are incapable of touching lives and bringing about change, then we are even bigger fools. Crystal, like all of us, wanted the same things in life: A place that's peaceful. A place to be loved. A place to be her true self.

On July 7, the charred RV sat with Crystal's body inside, her voice silenced forever. The coroner arrived and left with her remains. By sunset, the city tow truck had dropped her home onto a flatbed and pulled away. Crystal's treasured cat, Poppy, paced the sidewalk, lost and confused. No caseworker ever paid Crystal a visit.

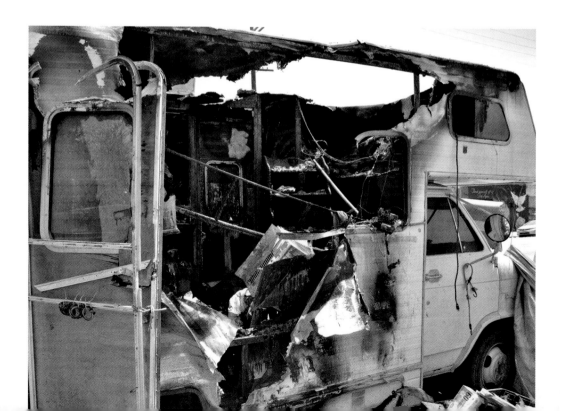

Two weeks later, I received an email from LAHSA informing me that, despite the several applications I had submitted on Crystal's behalf, they had been unable to locate her.

Her RV had been in the same place for years, as listed on the application:

**1892 W. Washington Blvd.**

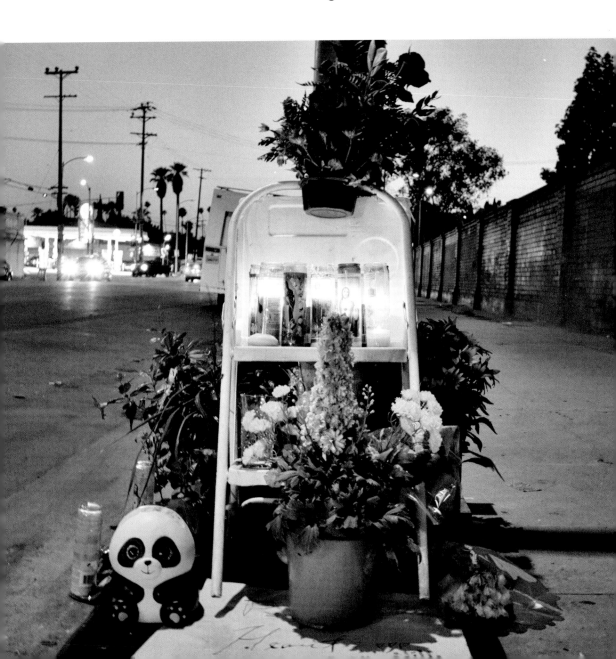

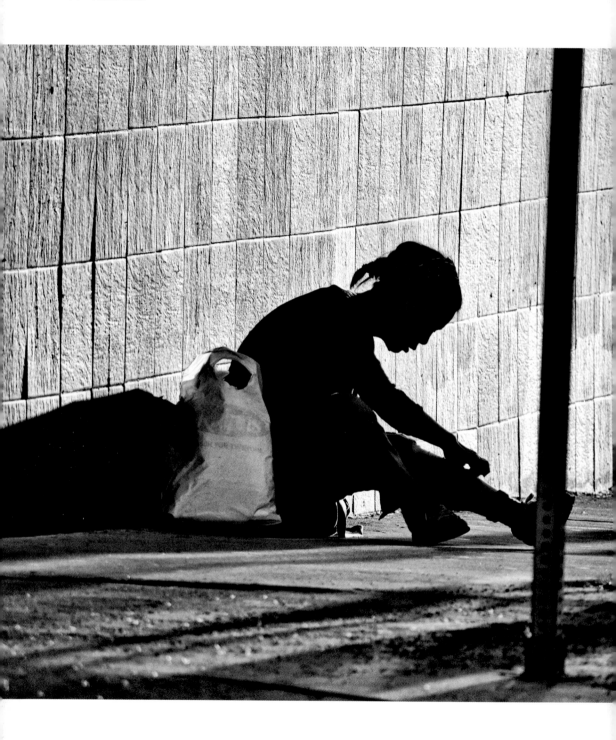

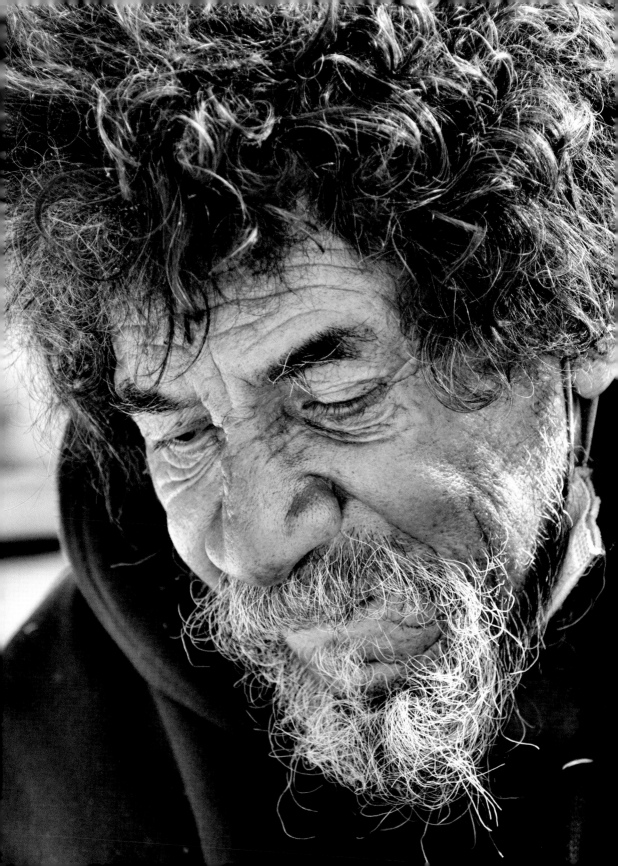

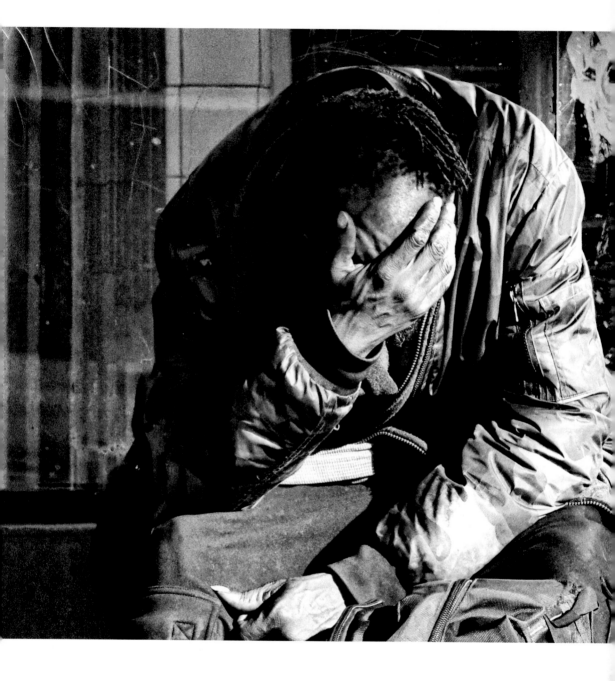

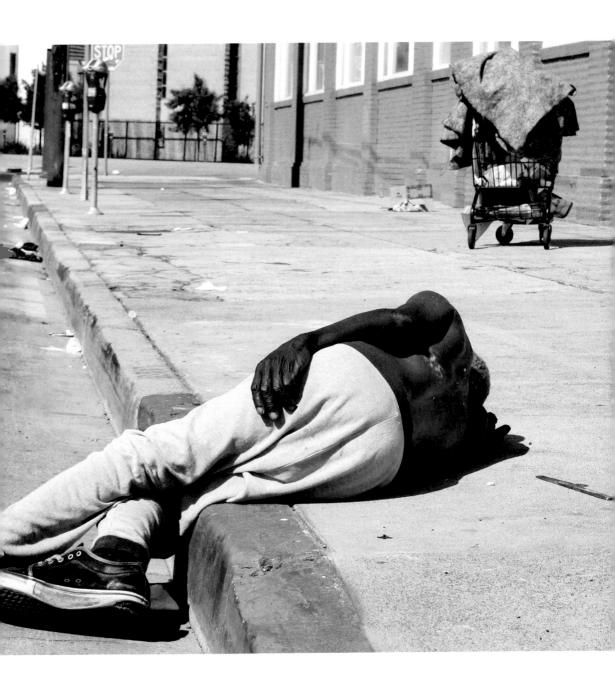

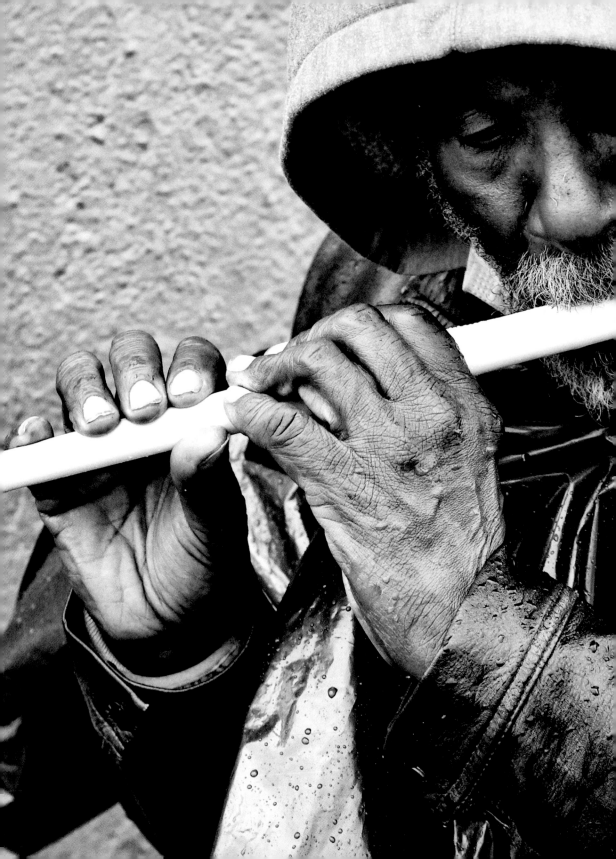

# DADISI

The harsh wind pushed the rain sideways and pelted the plastic bag that served as his raincoat. I noticed the syncopated pat-pat-pat the rain made as it hit the plastic. I don't remember exactly what was said as I stood outside the Fred Jordan Mission, but he stood out from the other men who shivered in the cold. We shouted greetings and small talk. Then the small-framed man with the bristly beard and rapid-fire delivery mentioned New York. Everything around us disappeared, and we stood in the pouring rain, talking music. His daughter was named after my favorite Coltrane tune, Naima, as was my cat in Brooklyn. And away we went. It was a lovefest, and I was smitten by his Afrocentric old-school vibe, a throwback to my own New York roots.

Dadisi Komolafe was and remains a hardcore jazz cat, the kind of musician I've gravitated to since I was a boy, the kind I idolized from way back when I wanted to join their ranks but didn't have the chops. Still, we were members of the same tribe and instantly recognized each other as such.

"I'm gonna play something for you," he said between the raindrops and wind.

"What's he gonna play, a harmonica?" I thought to myself.

Many have shared their illustrious pasts. Some stories are true, and others are dreams and imaginings of what they wish life had been. But this was different. Dadisi reached beneath the plastic, pulled out a small white fife, and lifted it to his lips.

Within seconds, I was experiencing something magical. I was excited. A smile appeared that I could not have erased if my life depended on it. Mesmerized, I watched the deft fingerings and heard the soulful notes of a virtuoso musician steeped in our music: jazz.

"You're a player, man," I shouted above the storm as Dadisi continued to fly. I could barely contain myself. "You a real player!" I proclaimed loudly, stating the obvious.

Dadisi had been "a player" for over forty years. A beast on alto and flute, and a hardcore Coltrane devotee, he's played with jazz luminaries, such as Nat Morgan and Horace Tapscott of the Pan African Peoples Arkestra, and recorded and toured across the US and through Europe. His own 1983 album, "Hassan's Walk", named after his son, placed him at the center of the Los Angles jazz scene. But he never signed a contract or received a royalty.

Hard and fast, he riffed like a boxer looking for a knockout. A beautiful soul rising on wings of sound before plummeting to the unforgiving streets below in a blaze of faded glory. But the street's grime could not disappear the talent within the aging lion. Wounded he may be, I thought, but dangerous still, he can strike with a flurry of notes that can stop a heart with its power and beauty.

His eyes water at the thought of all of those he's caused pain. His memories haunt his quiet moments. The sexually abused child. His siblings, scattered to the wind and placed into foster care. The mother, unable to slay her own demons, and a father who vanished.

Since that rainy day, we have spent many hours together. I have driven through the night, calling his name and hoping to see his head pop out from beneath a blanket or tent. We have shared great moments of joy and heartbreaking moments of disappointment.

"I have so many regrets," he told me.

He was exhausted and disappointed that, once again, he had spent days chasing a high that could never fill the empty hole within himself. He had awakened in a doorway, dirty and half-dressed. He was tired.

We think we know who someone is by what we see in front of us, but we merely witness a small moment of their journey. Someone's past is not their present—nor must it define their tomorrow. To know someone, we must know who they *were* as much as who they *are* and always leave space for hope and possibility.

I have come to know and care deeply for Dadisi. He is a wonderful man whose gifts are as profound as his challenges. His family loves and misses him. Unfortunately, I can't say what the future holds for my friend, but whatever it is, Dadisi will have a soundtrack for it.

"Everything I do is based on music. 24/7, the music is in my head. It never stops, even when I'm asleep," he told me as we walked the streets of Hollywood.

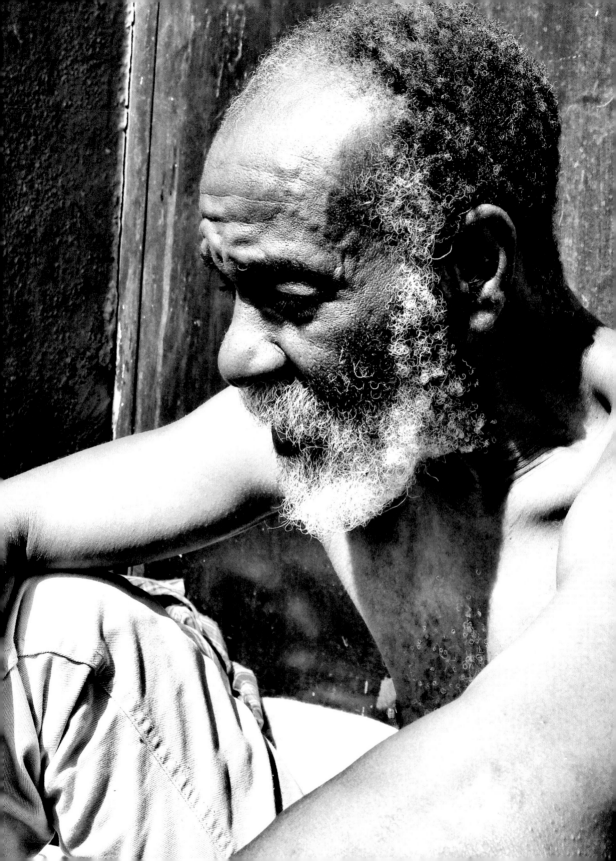

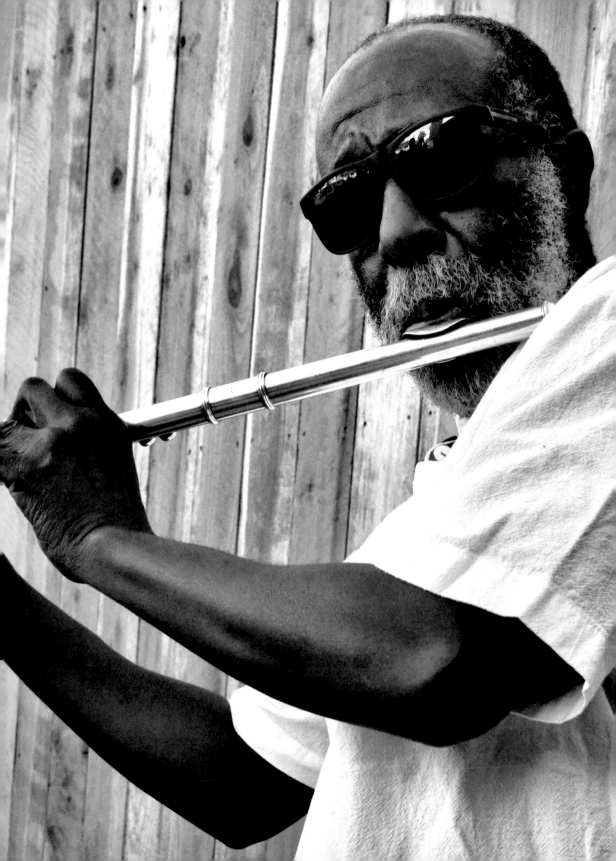

So for now, we sit dreaming of the future in the shelter that is providing Dadisi safe haven from the streets. He looks good. His white linen shirt and shades provide a dash of cool reminiscent of his glory days. He lowers the borrowed flute he has been practicing on. There are no guarantees, so we speak of tomorrow and hope for the best.

"One day, this is all gonna go away," he said with eyes searching the clouds above us, "and when it's done, they gonna put the toys back in the Monopoly box, and someone else is starting all over again," Dadisi said with a raspy chuckle.

Several months later I watched my friend enter his new apartment with flute and fife in hand. And as he had done on the day we met, two years earlier, he started to play. "You're a player," I whispered.

# LORI

"When you see somebody that's trying to get their life together, you need to have more empathy and compassion and help that individual instead of trying to tear them down all the time."

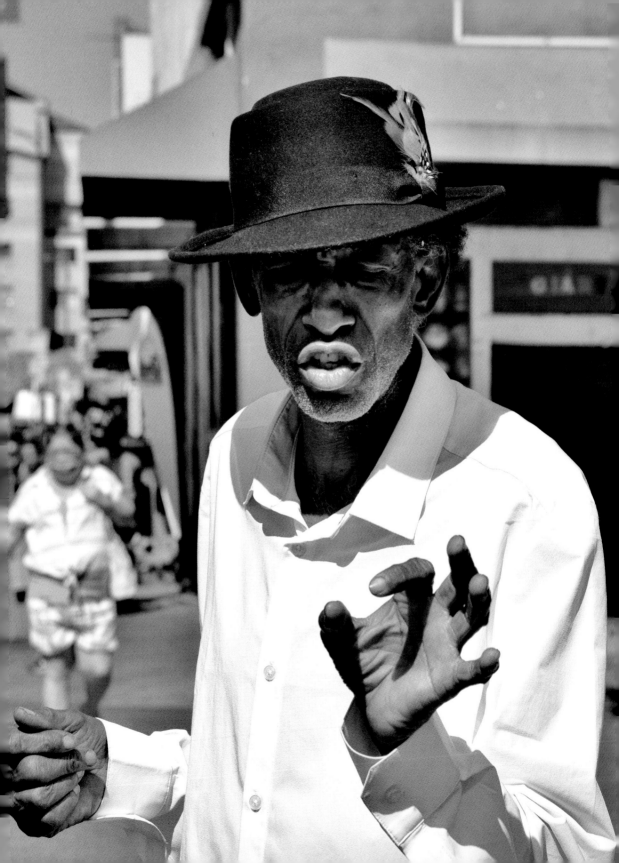

# DON

I'd been looking for Don for about a week. Such an interesting man, I wanted to continue the talks we'd been having for months. For several days, I passed the spot where he slept, but his trademark suitcase and small, neatly kept tent were gone. Then, one day, I returned, spied a pile of blankets where his tent had been. Surely it's not him, I thought—it wasn't his style.

"Don!" I called, and a face appeared from inside the blanket cocoon. And then he smiled. Don emerged in tattered sweatpants and hoodie. Gone were the perfectly ironed pants; crisp, white shirt; and hat he was wearing when we met.

All of Don's possessions had been stolen, including his prized wardrobe. He managed a gracious smile as he described the theft, but his eyes mirrored the disappointment of his loss. He had lost the belongings that gave him a sense of self and pride. It was something he could hold on to when street life closed in around him.

"I'm gonna play drums next week; they're having something in the park, and I'm gonna play," he said.

I didn't know if it was true or if he was clinging to a dream, but I nodded and encouraged him.

What do you do when everything you own and everything you are are taken from you? If you're Don, you dust yourself off and start all over again. With a gracious nod, he said his goodbyes and returned to his pile of blankets.

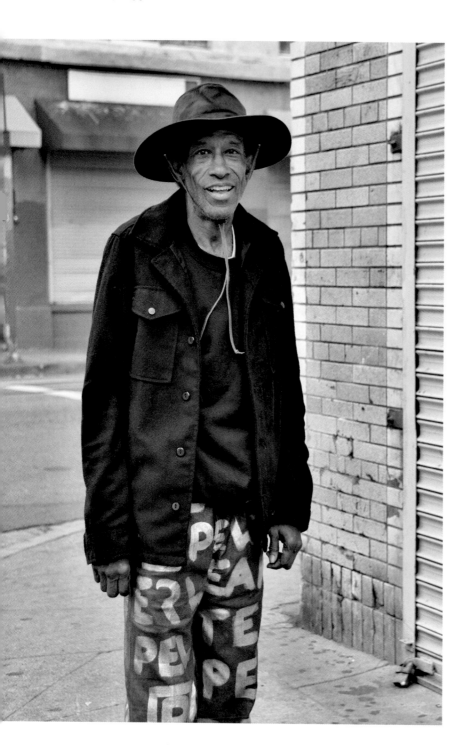

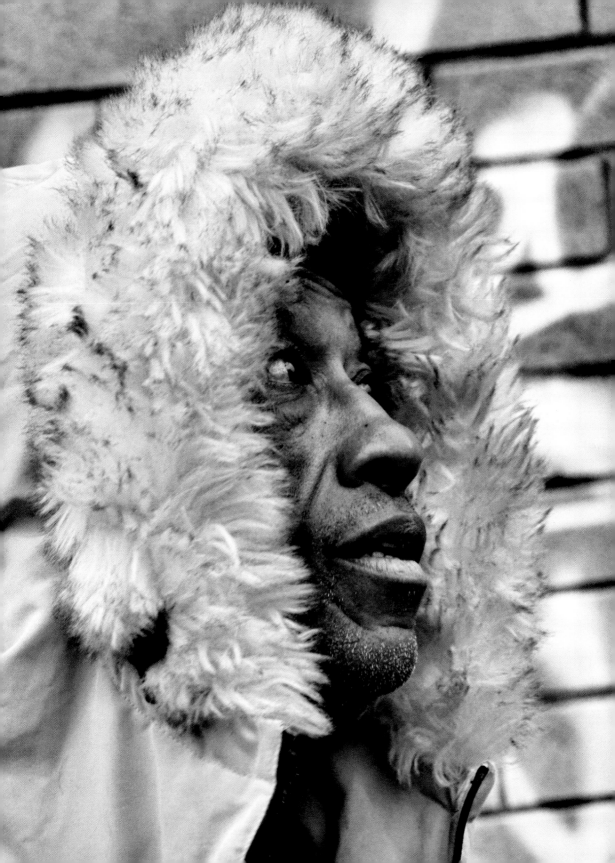

# LEE ANNA

With her curved spine bent over the shopping cart, Lee Anna spoke of stray cats, assaults, and her appearance in a Robert Downey Jr. film thirty years earlier. Her distant past feels like yesterday, and today is no guarantee for tomorrow, so Lee Anna lives day to day, memory to memory. I eased alongside her and fell into step, syncing my pace to hers.

I guessed Lee Anna must be seventy to seventy-five years old, but somehow, at four feet eight, with a hunched back and bad feet, she managed to push a cart four times her weight. Where does she get the strength?

"I love cats," she confessed. "I take care of them and feed them," she said.

In her words I recognized a generosity that I do not know if I would possess if I were in her shoes. But then again, I've been given someone's last slice of pizza when they had no idea where their next meal was coming from. I've been offered the coat off someone's back when they thought I might be cold. I've witnessed those who have nothing offer their last.

And I understood Lee Anna's joy in caring for a dozen feral cats who relied on her. Don't we all want to feel useful?

Lee Anna danced from one topic to the next, leaving little room for me to respond, but that was alright with me. My silence was all that she needed.

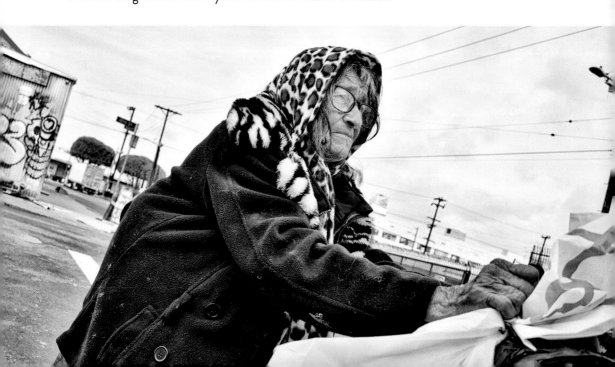

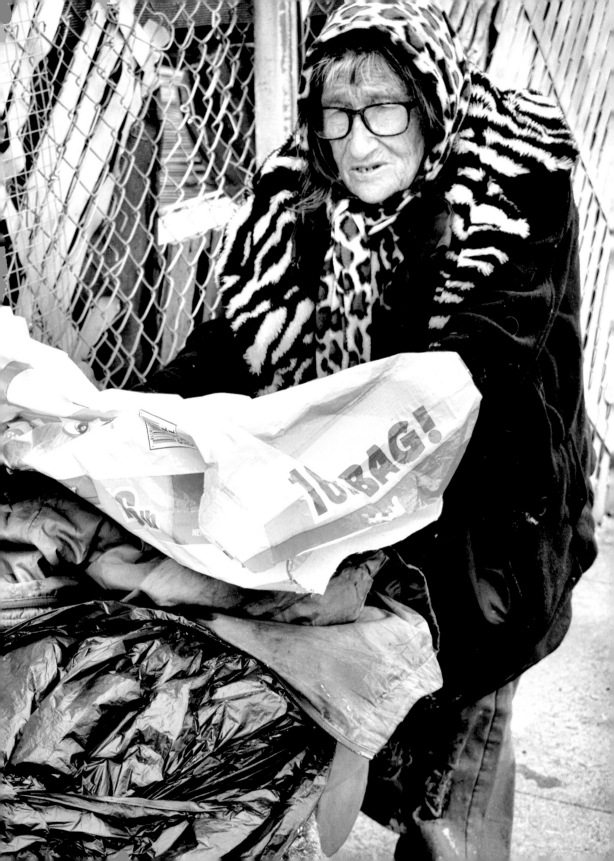

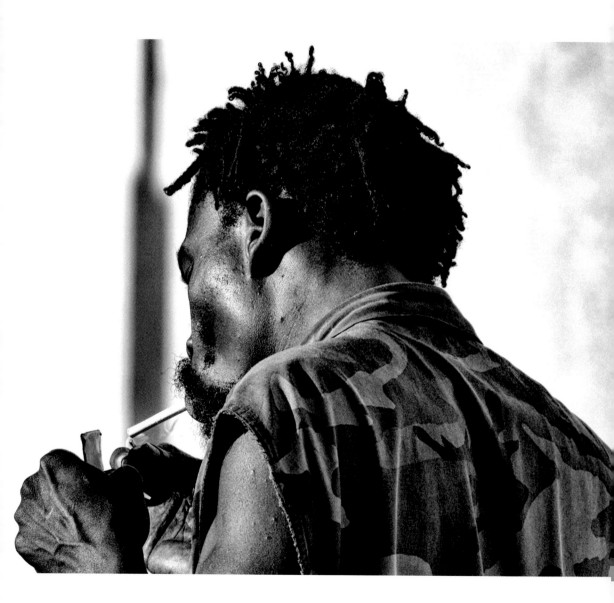

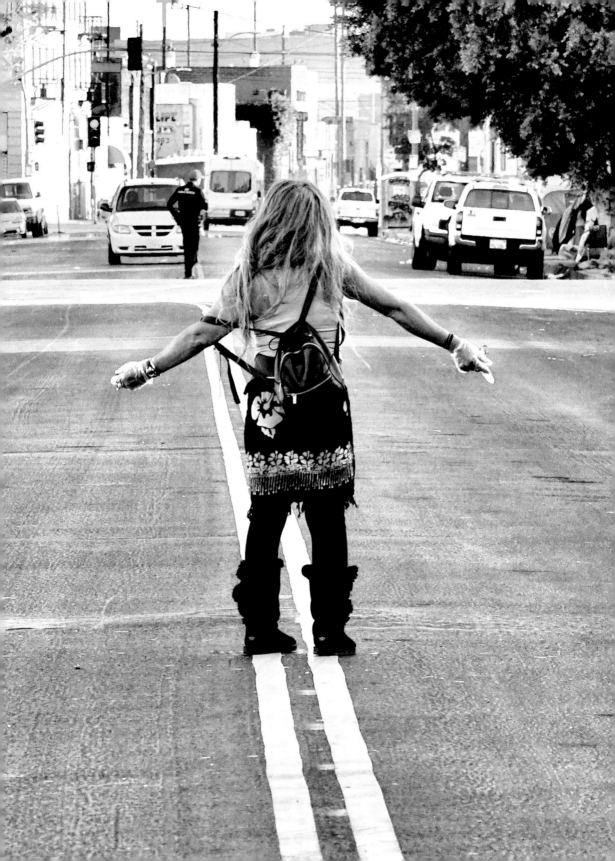

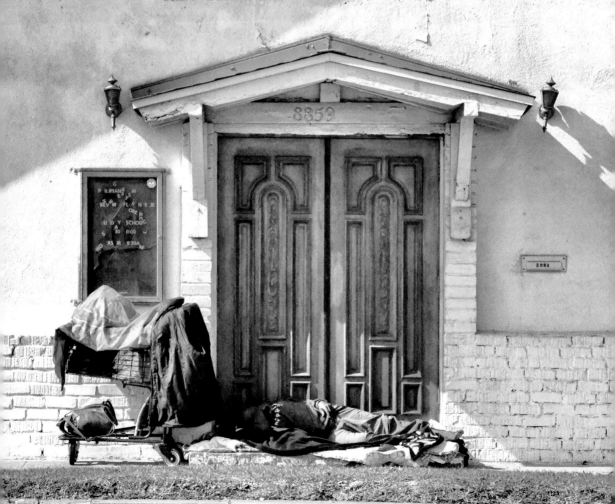

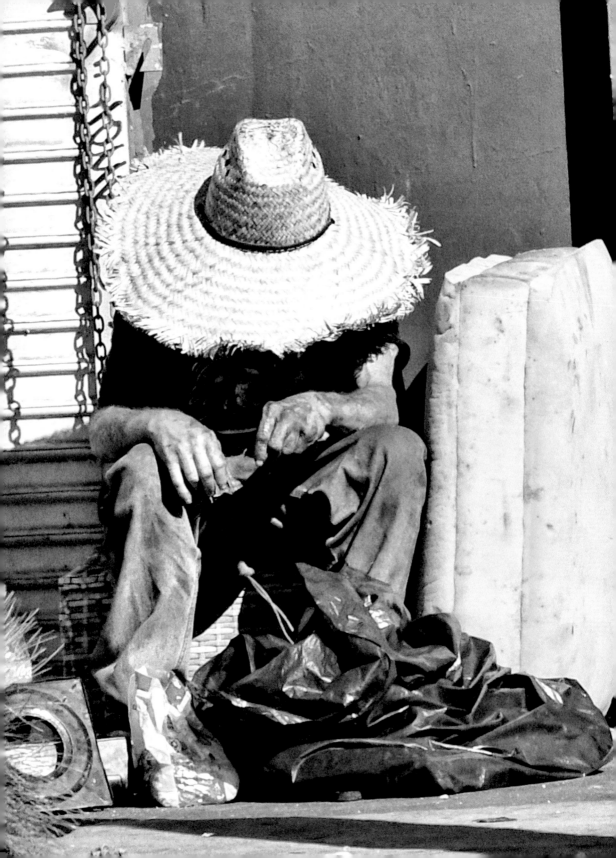

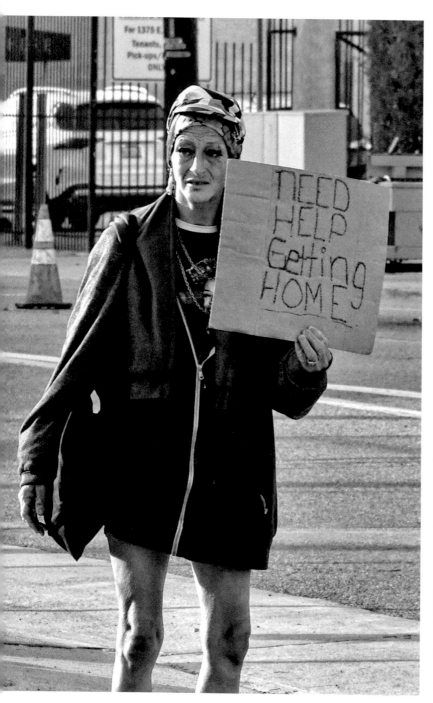
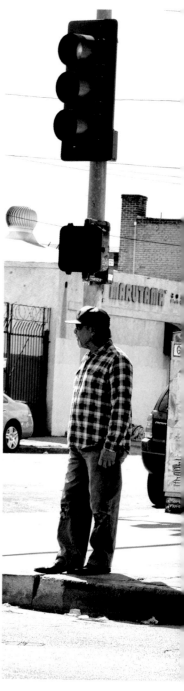

# CARLOS

Carlos sat beneath a large shade tree, his back against the brick wall of an old Lincoln Park office building. I drove slowly past and, noticing an aura of calm about him, I pulled over. He appeared undaunted by the scorching heat that had driven Angelenos to the beaches or inside to nap under an air conditioner.

Over the years, Lincoln Park had morphed from a predominantly Hispanic working-class neighborhood into a hipster destination with trendy tattoo parlors, coffee shops, boutiques, and restaurants. Now, Carlos rested peacefully on this discrete side street and allowed me to join him.

"When I see little kids with their mom and dad, I wish that was me," he revealed as a mother and child walked past us. Carlos had been shuffled between foster homes, juvenile detention centers, and prison. But it was the loss of his parents when he was a very young child that haunted him.

"I wish I could walk with my mom and dad and tell them . . . I love you," he said as he held an imaginary phone to his ear.

"I used to talk shit about homeless people, and look at me now. I went to jail, and I'm homeless too. It sucks," he said with a chuckle.

"Why did you agree to talk to me?" I asked.

He paused. "Because this could lead to something good for somebody," he answered.

# ALAESHA

My head is on a swivel as people move in every direction around me. Speeding cars narrowly miss homeless pedestrians, and folks meet on the corner and swap tales in the bodega's doorway across the street. The occasional luxury car cruises past, looking for some action. Life here is lived on high alert—a PTSD-inducing state of angst that can never be revealed to others, for to do so would expose a vulnerability that could be fatal.

Today, it's hotter than hot, and the heat rising from the sidewalk in glistening waves has coaxed many to stay inside their tents, hidden from the blazing sun. I came to find Michelle, who had not been seen since her unceremonious return from rehab four or five days ago. My search was unsuccessful.

"Maybe tomorrow," I thought to myself.

I turned the corner on Towne and slowed at the sight of a young woman sitting in the full midday sun, her left hand and right leg twisted uncomfortably in the wheelchair she occupied. I imagined how hot her blue sweatpants must be and wondered if ninety degrees on a shadeless downtown street was too much and if the scars on her knuckles were from a fall, a consequence of the cerebral palsy that gripped her.

She lifted her shirt and gently rubbed her round belly, unaware I was watching. I got out of the car and grabbed some cold water from the trunk without her noticing my approach. The sun seemed to focus all its energy on the small wheelchair-bound figure before me.

"How far along are you?" I asked, handing over the water.

"Six months," she answered, smiling and once again rubbing her belly as if to emphasize the point. Her light brown eyes were kind, and her hair, reddish, was lightened by the sun.

I asked her name, "Alaesha," she said.

Alaesha has lived on these streets for over ten years and, at twenty-eight years old, has survived despite her physical disability. Twenty-one percent of LA's homeless are physically disabled. There are thousands with arms so weak they must peddle their wheelchairs backward down the sidewalk, cling desperately on to broken-down walkers with mangled arthritic hands, or bend their scoliosis-ridden spines over a shopping cart for balance.

Who could that person have become if given support and a fighting chance in the beginning? But perhaps the real question is, Who might that person still become if we could provide the level of resources needed to guide them toward a different reality?

I was in no rush to leave, and Alaesha welcomed the company. She talked freely of her childhood in Oklahoma and about "getting out," as if it were a prison like the one where her twin sister died.

"They said it was suicide," she said, skeptical of the authorities who informed the family of the loss. But what's past is past.

Right now, the baby inside her belly worries her most, and her instincts tell her something's wrong. There's not enough movement, she tells me. But she doesn't know what to do about it. Prenatal exams occur during the occasional nights she's admitted into the hospital before returning to her tent and the meth habit she said she wants to kick. The meth keeps her up through the night, which is safer than sleeping and being caught off-guard by an intruder. Sleep comes seldom—drugs are her protector and her escape hatch.

"No beds, that's what they told me. No beds," she said when I asked about rehab. But that seemed like a blatant lie to her. How could a city not have a single bed for her? She cursed them. I cursed them too. So, life goes on day after day with little change.

Alaesha looked left, then right, then down the boulevard that stretched ahead of us. She owed someone eighty dollars, and they had threatened to beat her up. She wasn't afraid. She seemed to accept the inevitable assault as the price for living on the street. For now, she pushed the threat into the corners of her mind.

There is hope that the baby's father, also unhoused, might take custody, but there's no real plan, and I doubted his situation was any better than hers. It all seems so random. Alaesha knows that the baby will be the one to suffer the most. Tears come to her eyes at the thought of the life inside her. This isn't what she wants for her child. No mother wants this for their child.

It was getting late, so I lifted my camera to my eye, and through the lens I saw the tough little girl no one wanted, the wheelchair-bound woman who struggled to button her blouse, the expectant mother who knew that her unborn baby girl would bear the burden of the parent's choices, and the survivor who fought daily to prove her very own existence to a world that did not see her.

"It's hard to smile through the pain," she said softly.

"I know," I said as she looked for a match to light the skinny cigar she produced.

I could feel a letdown in both of us as I turned and walked to my car.

"Can I have a hug?" I heard her say.

I did not refuse. But mere hugs and kind words cannot undo what has already been done. If left unresolved, our past can simmer into a stew of hurt, hopelessness, and rage. This is what I saw as I rotated the lens into focus.

I saw Alaesha several more times over the next few months. Sometimes our meetings were light as she filled me in on her life and the upcoming arrival of her baby. Other times were more challenging.

I last saw Alaesha at a downtown bus stop, twisted in her wheelchair and surrounded by some neighborhood characters she considered friends but meant her no good. Stuck at a red light, I watched her pull the pipe from her mouth and exhale.

The baby bump was gone.

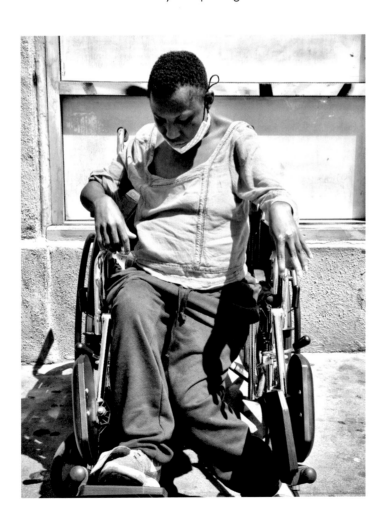

# MEMORIES

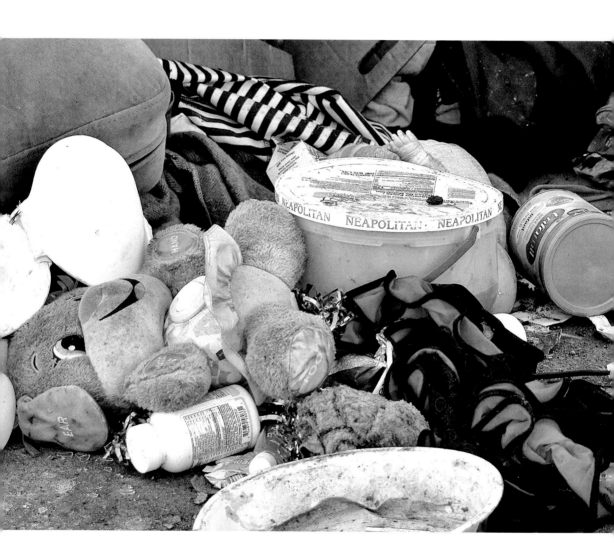

I don't know why I stopped. I've passed piles of trash a thousand times. We all have. We've learned to overlook it. Step around it. Ignore it and hold our breath against the stench of its decay. Even the best of us seldom takes time to consider the source of it, as if it just fell to earth from some unknown galaxy. But for some reason I can't explain, it was different this time.

I leaned in for a closer look, and it was, for an instant, as if I'd stepped into someone's life. That someone, a woman I assumed from what was scattered before me, had left the pieces of her life strewn across the sidewalk, where she pitched her tent and made her home until it was time to move on.

Someone's life cannot be grasped in a moment. Our lives are too complex, too filled with the ups and downs of living to be understood at a glance. But that didn't stop me from looking at the precious memories a stranger had reluctantly left behind, and I wanted to soak it in. I wanted to pay attention to every detail out of respect. And so, there I stood, hovering above the pile.

My eyes fell upon a baby's stuffed bear and the bra that lay by its head. A doll's tiny hand reached skyward from behind a ready-to-eat Italian meal, and a 12.5-oz. can of Enfamil Infant Formula rested against the doll's back. I pictured her, the mother, I mean, carrying these precious items with her as she moved from one location to the next. Was she clinging to reminders of the child she left behind? Or was her baby with her as she sought comfort, support, and a safe place to rest?

Hand sanitizer, dried fruits and nuts, Pringles, vitamins, a candle bringing good fortune, and a single piece of lingerie. Silently I inventoried all of it. It's all here, "trash" left behind but surely not forgotten. And it occurred to me that the piles we walk thoughtlessly past every day are not trash at all. Instead, they are the intricate details of someone's existence, with all its joy, laughter, sorrow, and pain.

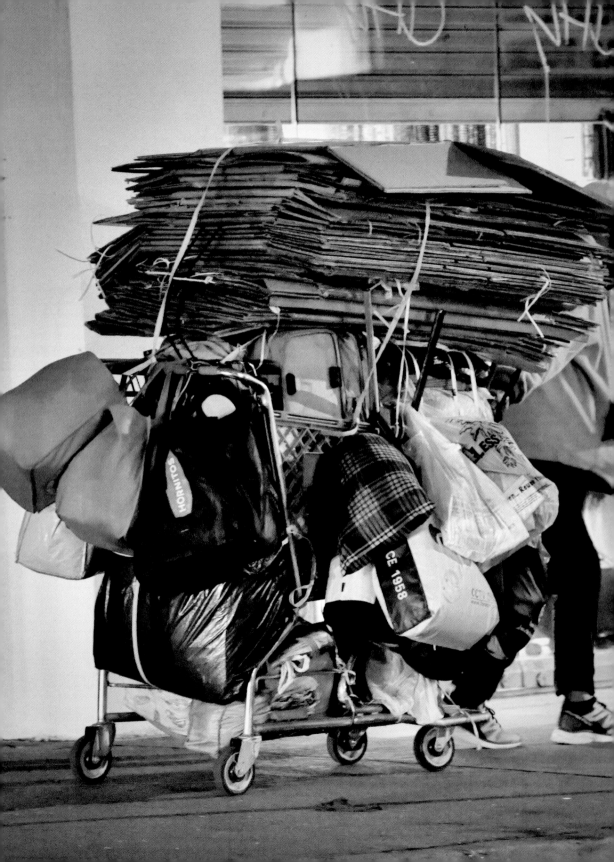

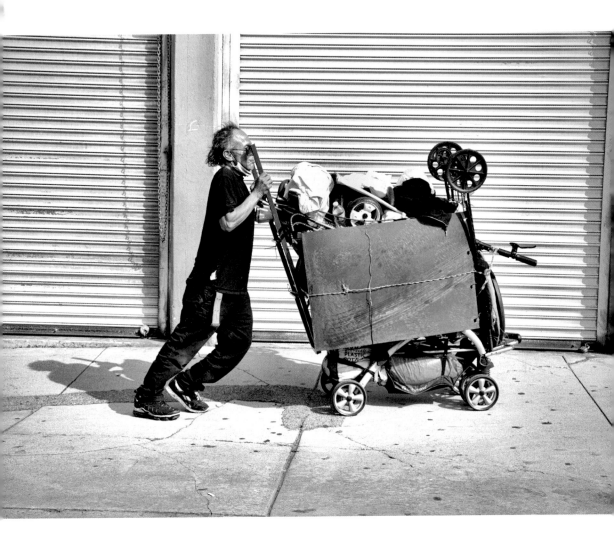

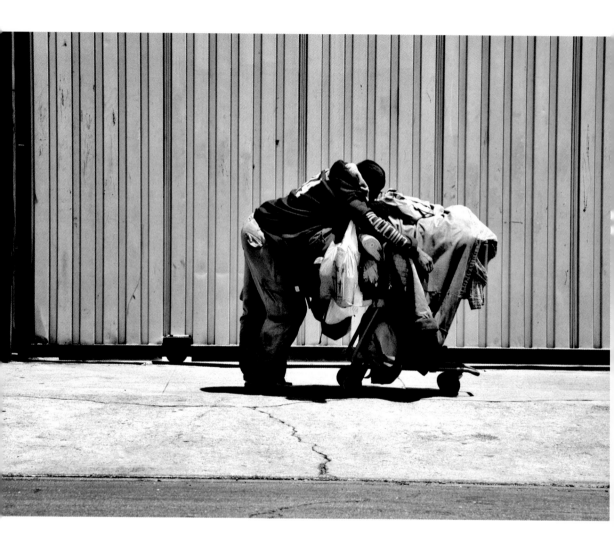

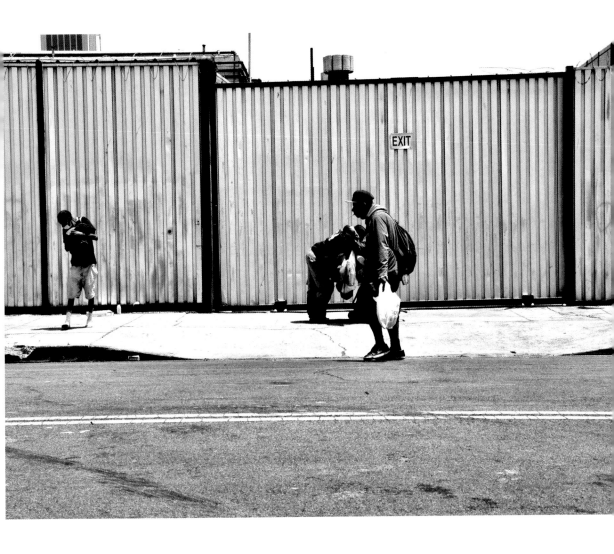

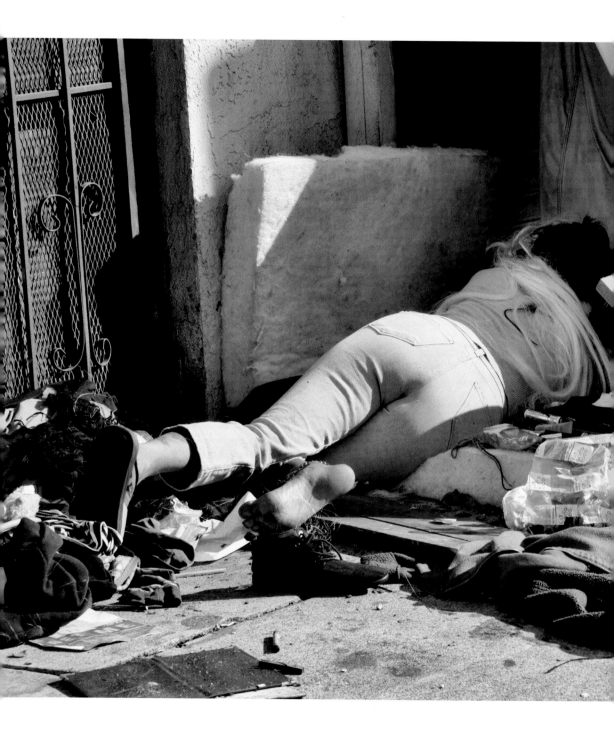

# SASHA

I had seen her storming down the middle of the street as cars slowed to avoid her during one of her frenzied rants. She had become a regular stop as I moved about LA, catching up with the people I knew on the street. Now, she was plopped down comfortably on the sidewalk, engrossed in whispered conversation with herself as her pen left its mark across the pages of her ever-present notebook. She wrote furiously, filling the empty pages from first to last.

I sat down beside her and eyed her notes, a manifesto of some kind. Her handwriting was neat and practiced. She is smart, and there is creativity lurking in the fog that is her mind. I imagine the little girl with a lifetime ahead of her and something to say.

Her name is Sasha, and she has two daughters—somewhere. I know because Richard told me so. They had been a couple, but they now lived in separate tents, and though he tries to protect her (his words not mine), he's no match for the men who arrive in darkness and drive her away, only to dump her back on the street when they are through.

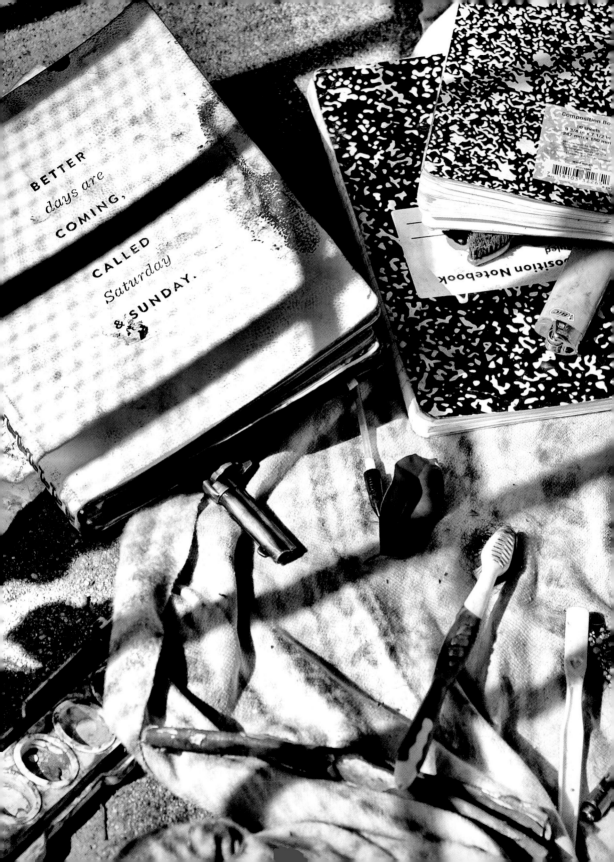

"What would I do if I lost my child to the street, mental illness, drugs, or something unknown to me, without the ability to help?" I asked myself. The thought shook me to my core.

I think of the teens and young adults, the LGBTQ+ and others, all struggling to find their way when so many have turned their backs on them. Only a few years ago, Sasha was one of them.

Suddenly, she stopped writing and grabbed the dirty toothbrush and the child's watercolors on the ground beside her. Remnants of red, yellow, and blue remained in the little plastic cups. She dipped the toothbrush into her impromptu makeup kit and smeared paint across her eyelids and cheeks, turning her petite face into a mash-up of color and days-old dirt.

"I'm going to show you my summary," she said proudly before disappearing.

Looking down past a child's cap gun, her lighter, pen, toothbrush, and bracelet, I saw the journal she had been writing in.

"BETTER days are COMING CALLED Saturday & SUNDAY."

BETTER days. Could that be the wish that keeps her going?

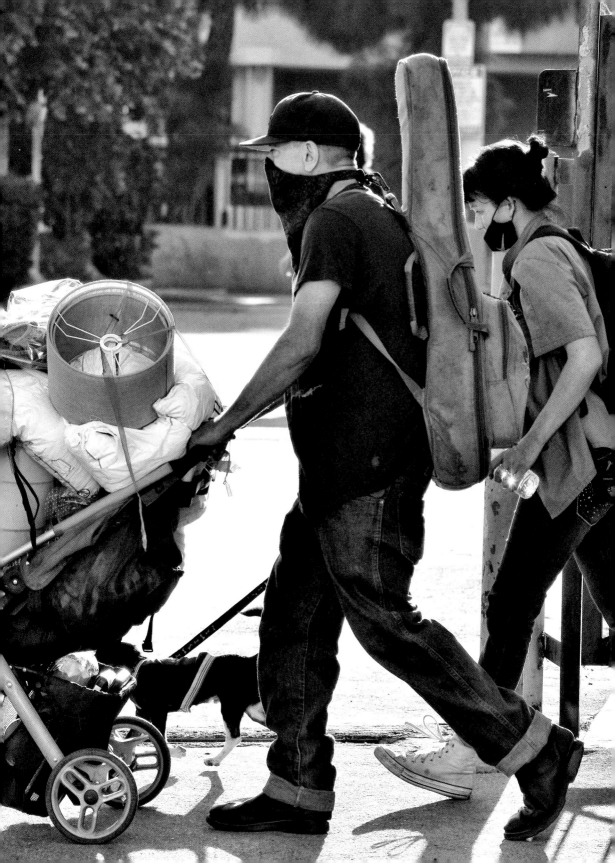

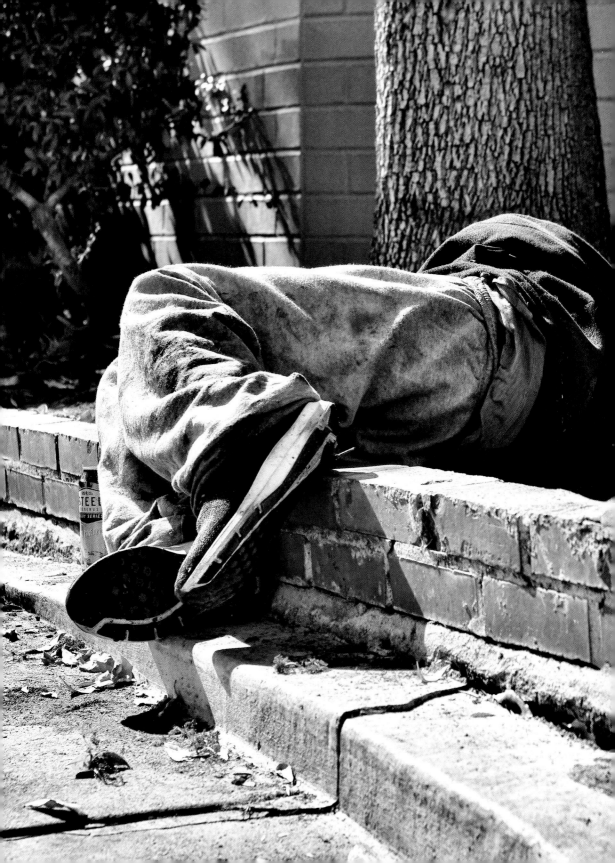

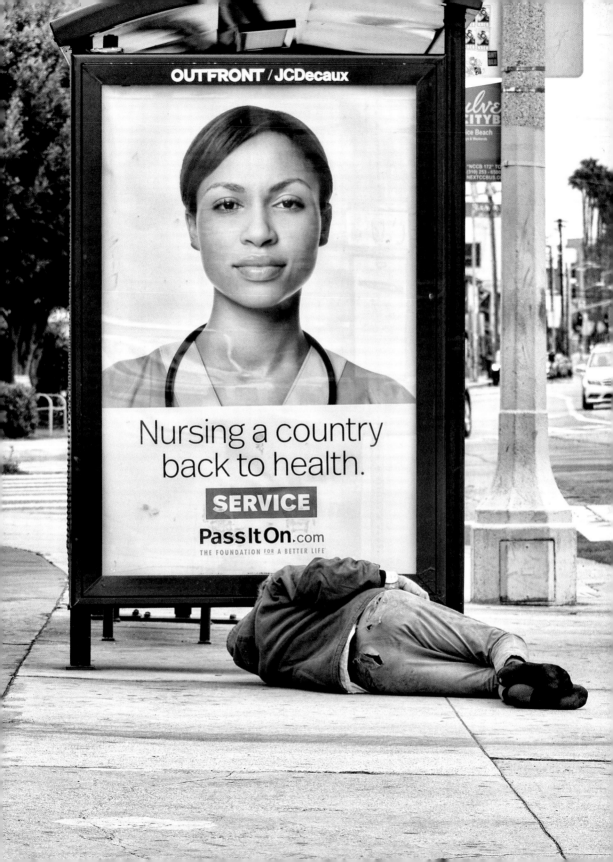

# JUICY

The sun, still low in the sky this Sunday morning, softened the rough edges of Skid Row. The streets were empty and quiet as "Juicy" emerged from her tent, carrying clothes and a wash bucket to the fire hydrant on the corner. She wrenched it open and the water appeared, glistening like crystals flying toward the sun. She leaned down with her palms skyward, caught the wetness, and washed her face. She has endured. She has survived. She pressed her dampened hands to her face once more, then started on her clothes.

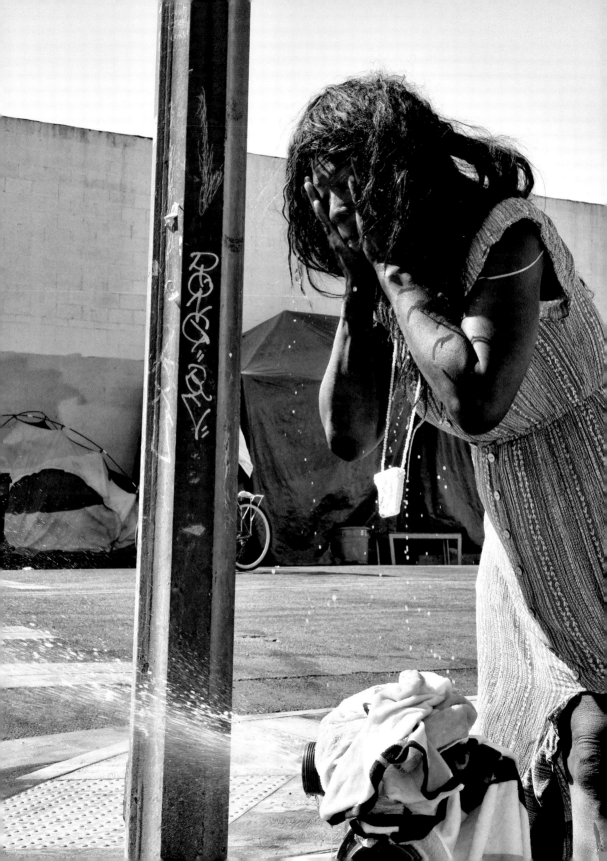

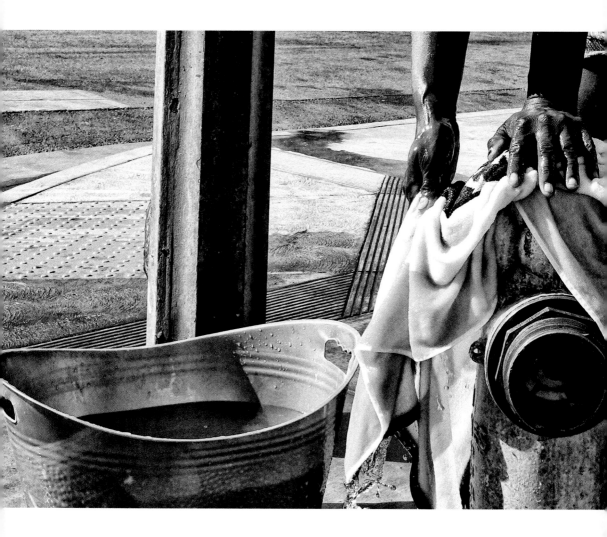

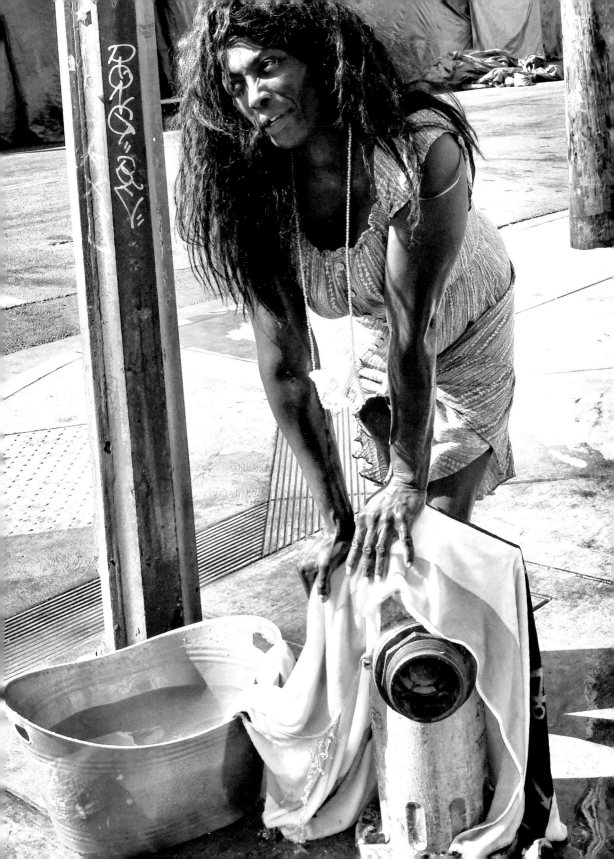

# GARDNER

His eyes danced—his smile was genuine—his words were few. Texas to Vietnam—to LA—to the street. Gardner shared his story without bitterness or regret.

There was an air about him that intrigued me. Propped up against a wall and smiling, his prominent nose reminded me of a beloved and long-deceased uncle back home. I felt connected, and this connection reminded me that we weren't strangers at all. We were simply fellow travelers on different paths.

Gardner still doesn't say much, but his melodic "Oh . . . hi," has become a destination.

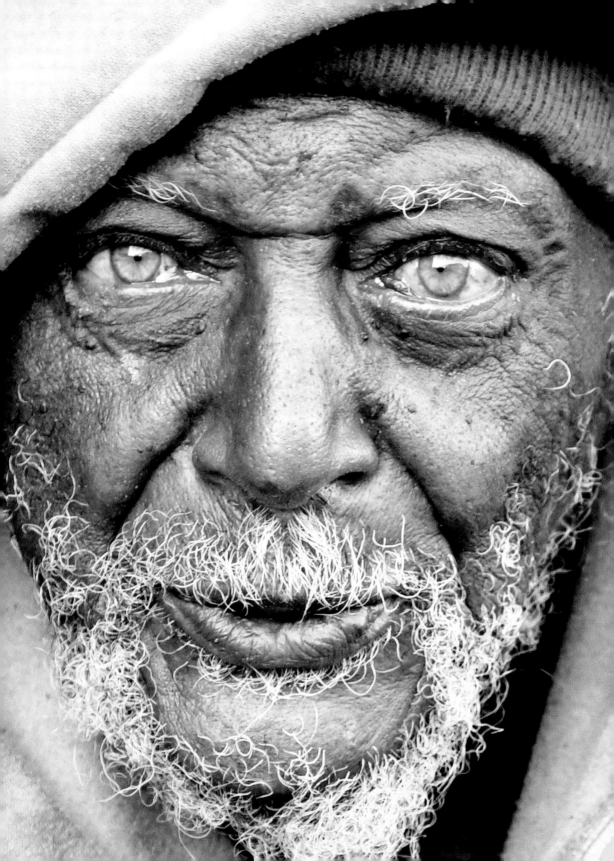

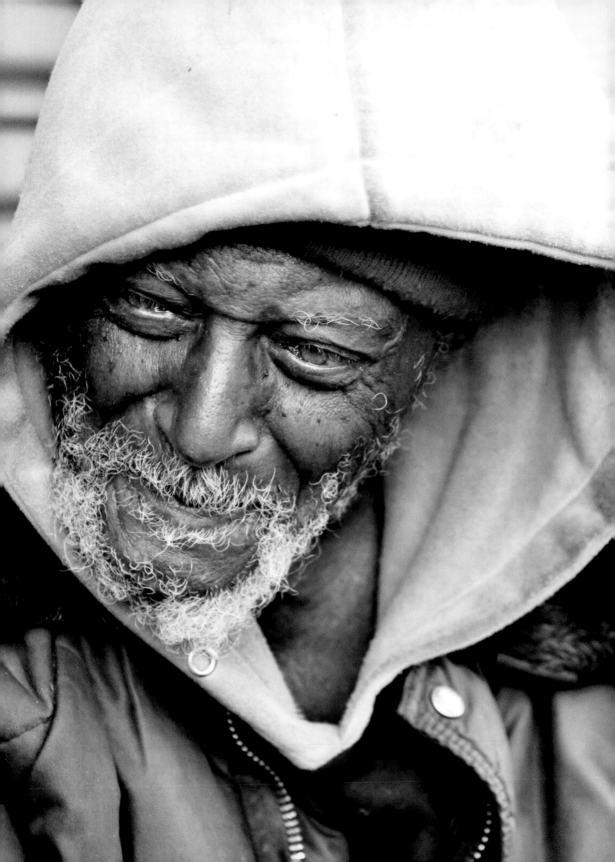

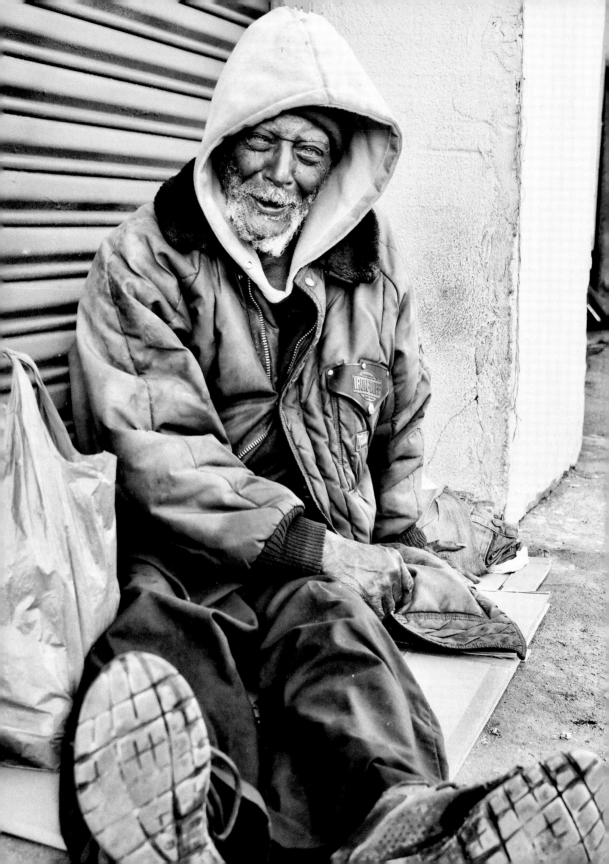

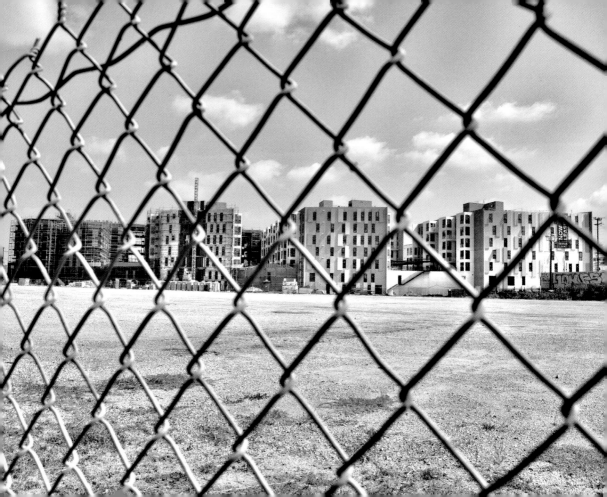

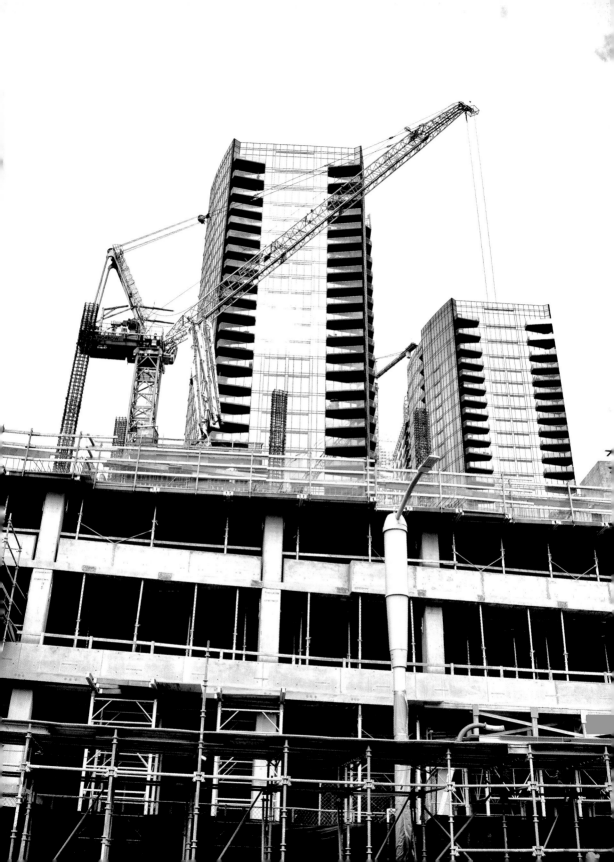

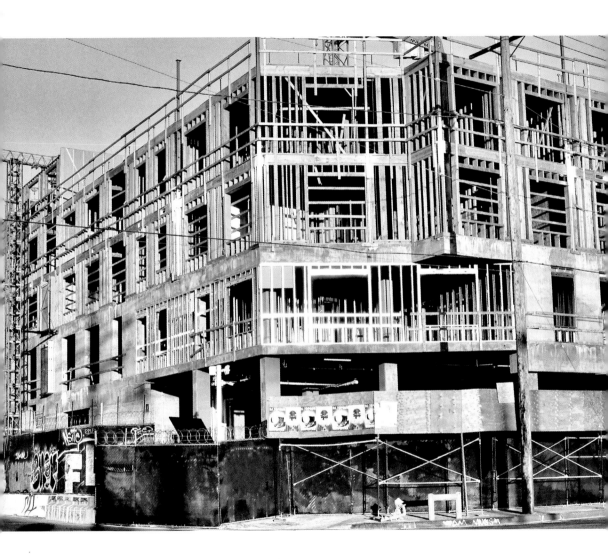

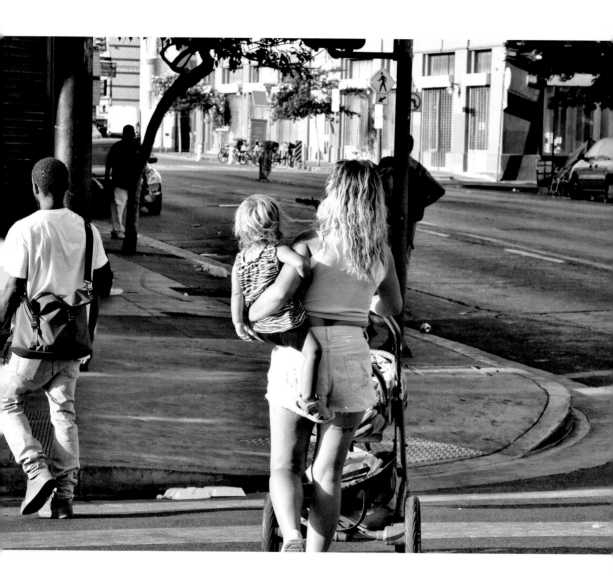

She clutched the child to her hip and glanced down at the other, asleep in the stroller she pushed toward home. A studio on one of the Row's busiest streets, surrounded by missions and those who need them.

Who, I wondered, thought it was a good idea to provide families with shelter in the middle of the city's most challenged neighborhood?

Is this the best we can do? The question haunts me.

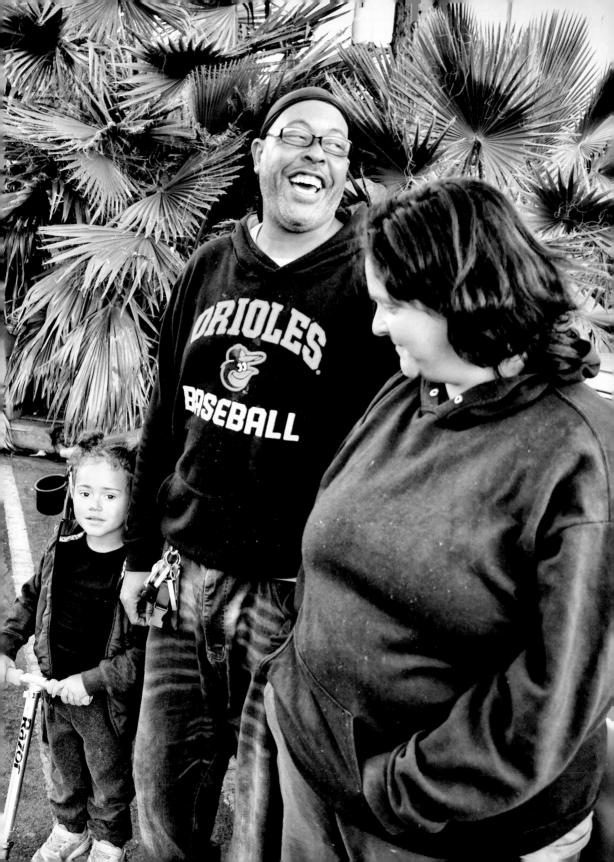

# FAMILY

She held up three fingers and silently counted.

"Four," the girl with the bright eyes stated proudly while moving to her father's side and leaning into him as her mother watched with a smile. Her name is Naveya, and I felt the boundless love of her parents, Eric and Brianna, a deep love that sustained her on cold nights in the back seat tucked beneath a donated blanket.

In her eyes, I glimpsed a fear of the unknown, of life's uncertainties. In her world, there were no playdates or other little girls doing little girl things. No preschool, babysitters, or cookies baking in the oven. That was some other child's life.

Meanwhile, her parents' eyes masked their worst nightmare, a nightmare that tomorrow would be just like today. When we first met, Brianna and Eric worked at the Santa Monica Pier, catching the train at the end of their street for a ride to the ocean and a few hours barking for customers and making minor repairs on the rides and games. Unfortunately, the part-time jobs never paid enough to save the first and last month's rent it took to get into an apartment. That was always beyond their reach, just like the Section 8 housing everyone talked about but few seemed to have. And any hope of saving money ended when childcare became an insurmountable problem.

"If we had the same shift, we didn't have no one to watch her," Brianna told me. "Then, I got blood clots in my legs. I was in the hospital and had to stop working," she explained.

Eric listened. He stopped working there when his back went out. They were older than the other workers, who they thought of as "kids."

Eric smiles constantly.

"What's the purpose of being sad?" he said, not really asking a question. He was stating a philosophy that enabled him, enabled them, to endure. "How does he do it?" I wondered silently.

"I mean, this is my life right now. My life's story," he elaborated as he bent down and put the small winter vest on his daughter. "I'm not proud of it, but God got my back," Eric continued. "He got my wife's back, he got my daughter's back."

The evening chill was coming, and Christmas was only weeks away.

Earlier, Eric was on the phone with a Los Angeles agency that distributes vouchers for a few nights in a motel when the caseworker suddenly "had to run" to handle an emergency.

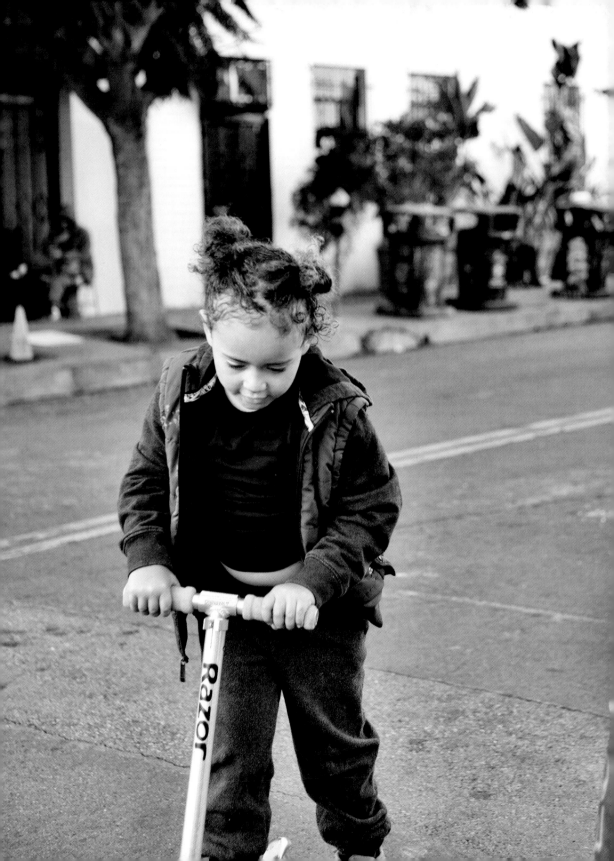

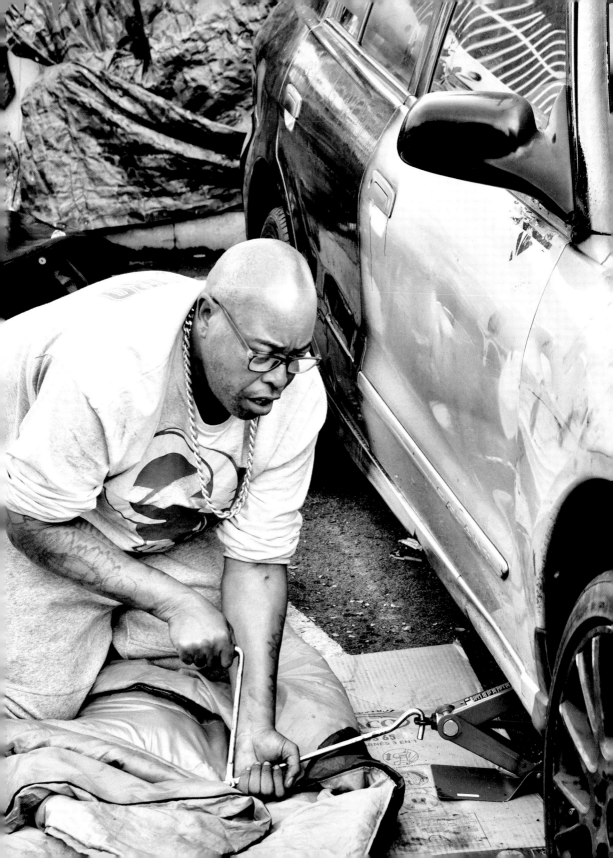

Eric hung up with the promises of a hotel voucher and a return call still ringing in his ear. That call never came. He sold his food stamps and got them out of the car and into a motel room for the night.

There was talk about a move to Las Vegas. Support for families like theirs is more accessible there, they told me, and the cost of living is drastically cheaper. But the car wouldn't start, Vegas was postponed, and when they finally got there, things didn't work out as they'd hoped.

They're back now, and after bouncing between their car and a Skid Row shelter, the family has finally gotten temporary housing in a motel. Brianna's dream of entering a college certificate medical assistant program came true, then had to be postponed. Eric is working back at Santa Monica Pier, and Naveya continues to play alone. After years of trying, the family is in a local motel awaiting permanent housing.

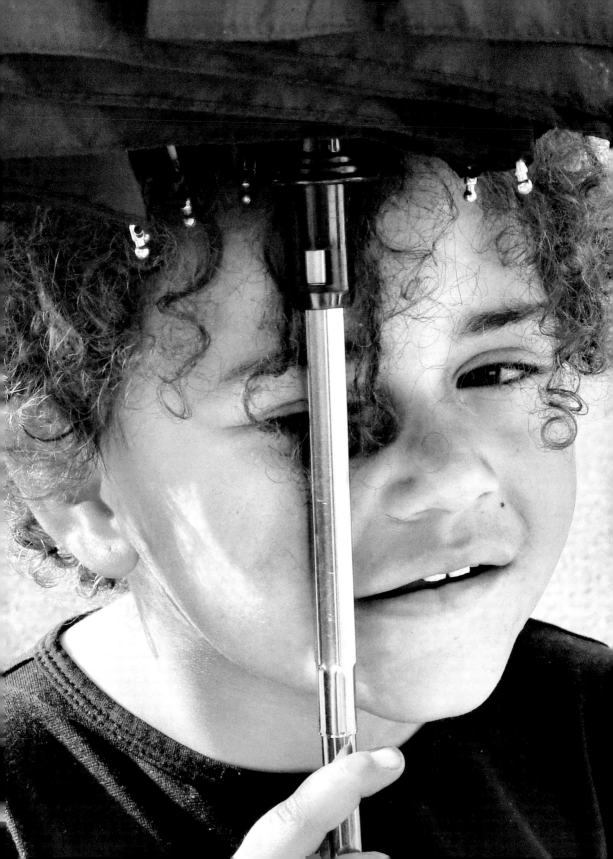

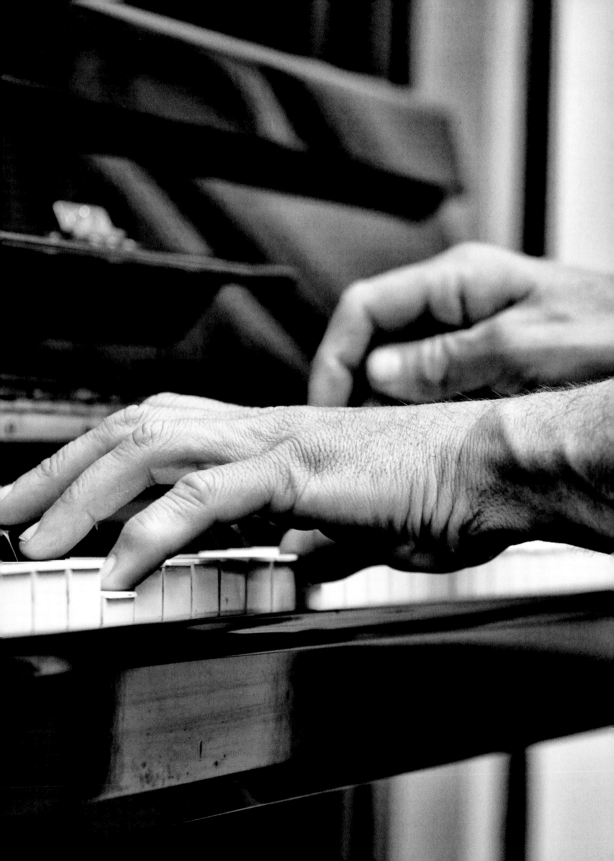

# CHADWICK

The entrance of Union Station opened to a majestic hall with sitting areas lining a walkway that led to its platforms, ticket booths, and assorted vendors. Commuters and travelers arrived and departed with eyes straight ahead and not a moment to spare. Their footsteps and hollow voices ricocheted off the walls, and among the crowds were the unhoused, who sat for hours. Or until the security guards encouraged them to move on. The scene was as I expected.

But I did not expect the music. In the corner of this grand space, a piano sat day and night, waiting for anyone to pay attention to it.

Some struck the keys out of anger, others out of love or a desire to express the inexpressible. And now the piano was in the possession of someone who knew it well and touched its keys with care. The muffled voices filling the station gave way to chords that soothed and attracted me.

Chadwick's fingers rose and fell dramatically. Lightly. Waves of power, elation, despair, and sadness rushed through him and onto the black-and-white keys at his fingertips. Then, suddenly distracted, he stopped.

"I don't like that one," he mumbled, critiquing himself before diving into another improvised composition. I watched for hours.

"I learned to play in school," he offered.

"An Asian girl, that's who got me going. Teaching me. That was in Job Corp, and she played 'Ninety-Seven,' the Titanic song," he shared.

"She'd be at the piano, and I'd be right next to her. Everything she did, I did," he continued.

His mind raced, and Chadwick's thoughts were a puzzle that he tried to solve right before my eyes. I imagined him at the girl's side and her frustration when he watched her play and effortlessly copied her note for note. He was untrained and played by ear. I also imagined him as a boy, trying to slow the raging river of images and thoughts running through his head without stop.

"They said I had ADHD. They had me in the hospital. They studied me . . . and that Asperger's crap." He let the thought linger without finishing.

He rocked in place, trying to slow down a brain that only settled when he was playing.

"You know what it is," Chadwick continued, as if finally identifying the source of all his pain. "My dad, before he died, he told my mom, 'I wish I'd done better with Chadwick.' Now, why would you say that? This was before I even got in trouble. What did I do?" he asked.

Drugs have been Chadwick's escape. A respite from his mental and emotional challenges. An escape from the memory of his father's words.

"I want to love. I don't want to be happy—those are emotions. I don't want something sexual. I want a relationship. That's what I need. I want joy!" Chadwick exclaimed.

Meth was a short-lived road to happiness, but joy was the sustainable path to purpose and meaning. This he knew.

Chadwick played a bit longer and stood when he was done. Footsteps and voices danced inside his head, replacing his beautiful music. He walked away with arms swinging wildly. And he looked back . . .

"Without people, without anybody, there's no me," he said over his shoulder.

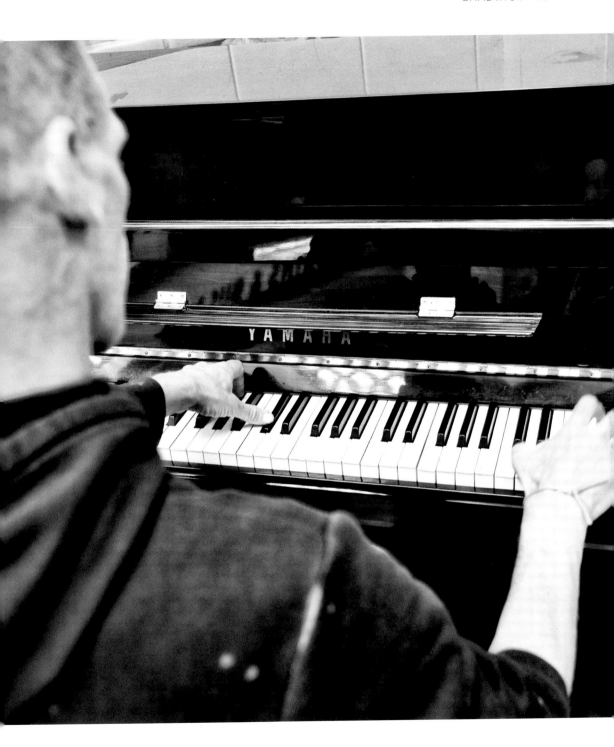

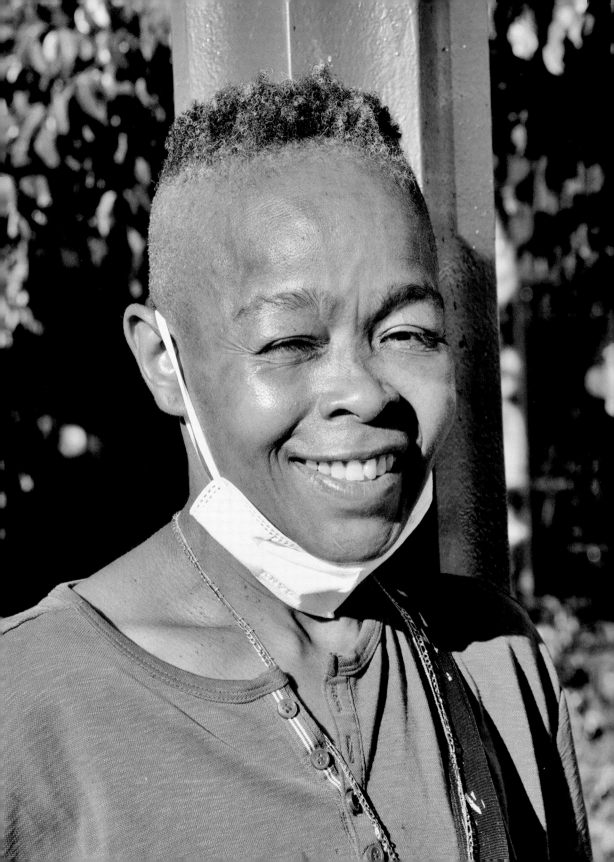

# SHORTY

"The first abuse came from home, so I had to learn early how the people closest to you can hurt you," Shorty told me. "One of my family members had an issue," she said, identifying her abuser without fear but surely with a sense of betrayal.

A million pounds of resilience in a ninety-pound frame—that's who Shorty is. We stood outside the downtown Los Angeles bus station that served as a gathering place and portal for thousands who arrived with dreams of Hollywood and stardom. But a look around revealed the truth. This is where dreams come when they die. This is where Shorty came to bum cigarettes.

"I'm a single female who's totally gay," Shorty said. "They don't understand that. They want to beat you up and do all kinds of things to you. No one should have to be stepped on, stomped on, or abused. I got stabbed six times, two broken ribs," she continued, touching the bruise near her left eye, the latest assault.

"Predators!" Shorty spit the words out and stared at the men hanging around the bus station. And then she cracked a joke. She's learned to use humor and a disarming smile to conceal the hurt. But pain has a way of revealing itself from the shadows.

"How do you make it day-to-day?" I asked.

"I use drugs," she answered directly. "You see, you come here for a visit, then you go home," she declared. Shorty wasn't angry or resentful. She was merely stating the truth.

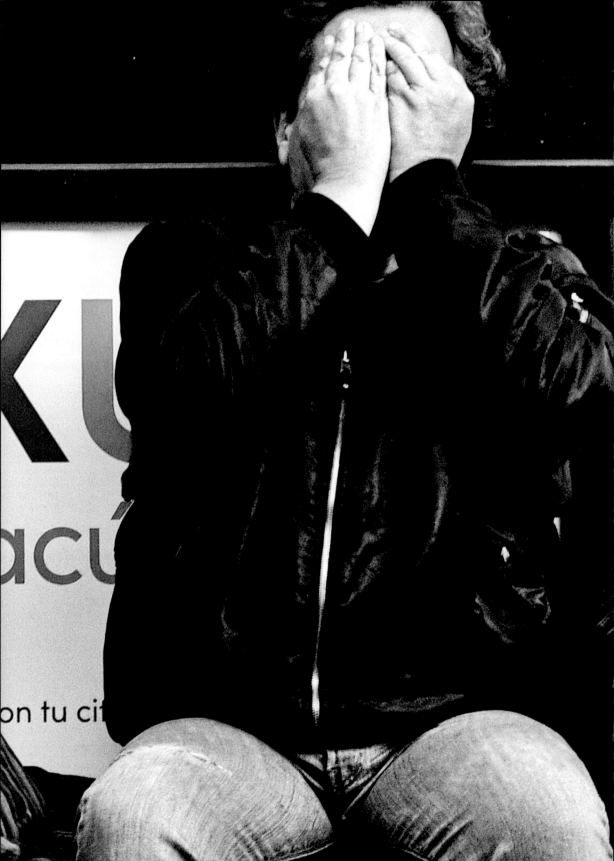

# IN PLAIN SIGHT

Beyond your view and out of earshot

I wait to be seen and heard

Fading into the background
like a shadow

I've lost myself and don't know
where to look

But here I am—hiding in plain sight

# MARIA

I could usually find Maria seated yoga-style at the entrance to her neatly kept tent. Her hair was moussed and dyed a pinkish-purple blend, and her clothes were always freshly washed. Inside her tent sat several neatly stacked piles of clean clothes and household items for a kitchen. Stretched behind her was her bed, with clean linens and a comforter.

Though she had created as comfortable a home as possible, this was still a tent, and Maria reminded me of a canary whose cage door had been left open but was too cautious to venture out. From her sidewalk perch she surveyed the goings and comings of her tent-dwelling neighbors and kept a close eye on the strangers who moved up and down her street, which included me. But I wasn't a stranger for long.

"You've got to get her off the street," Maria ordered me. She was talking about Michelle, who lived in a tent nearby. I had photographed and interviewed Michelle for months, and Maria would call me over whenever she'd disappear for days or weeks.

"That girl is gonna die here if you don't do something," or she would say, "Can't you get the police to come get her before something happens to her?"

"It doesn't work like that," I had previously explained. "You can't make people do what they don't want to do, Maria." And she would shake her head as if I'd disappointed her. Truth be told, I was disappointing myself.

As our conversations continued, it amazed me that she seldom spoke of her own need to get off the street. At least in the beginning. When we met, she proudly told me she would be getting housing soon. It was arranged by the Skid Row church she occasionally attended and LAHSA, Los Angeles Homeless Services Authority.

"I'm going to get an apartment any day now in Lynwood," she chirped confidently. For months we chatted about the move. She was looking forward to making friends.

"I hope I can have a television," she said in gleeful anticipation of the move.

I was so happy for her. I had not met many who had gotten housing, and I wondered how long this senior citizen could survive before the violence that surrounded her came knocking at her door. But slowly, she stopped talking about the move. The caseworker who was helping her had stopped coming to see her with updates. She asked me to call him, and I did. He seemed nice enough, but nice wasn't getting us anywhere. Like many of the caseworkers I encountered, he was overworked and underpaid, and that doesn't help morale or job retention.

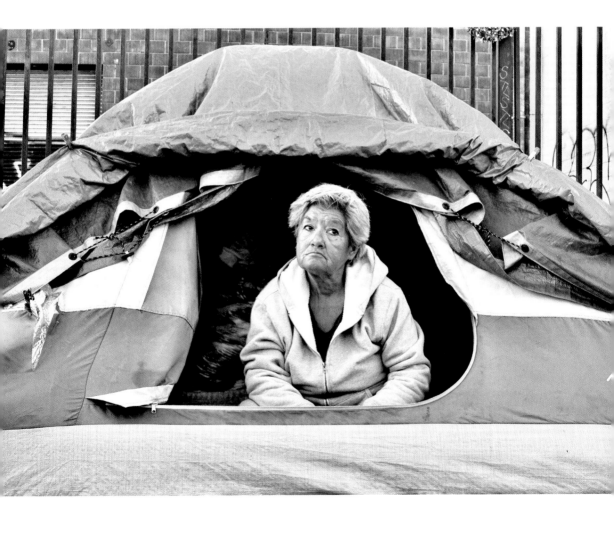

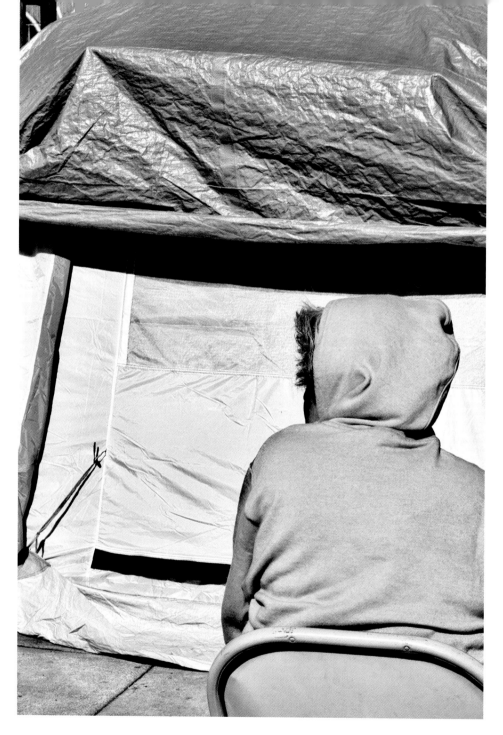

(Maria's last morning outside her tent)

Occasionally she was given dates for this and plans for that, but for months nothing happened. How many times must she hear, "It's on the way. Just hang in there."? How many times am I going to deliver someone else's bad news and watch Maria's eyes sadden and her smile fade when the promises go undelivered, which they always seemed to do?

After almost a year of knowing her, for the first time, Maria cried. Her lips quivered in the cold December air as tears streamed down her face.

"Keep the faith," I said, but it sounded pointless. I promised to reach out again to the caseworker with little confidence that it would lead to anything.

More months passed, and I arrived to find Maria's tent and belongings in a heap, abandoned on the sidewalk. She had been taken to a shelter, and though I had no idea where she was, I was relieved. But following a disagreement with another shelter client, she landed back at her old perch, watching the world pass her by.

Little changed. Maria's birthday came in July with cupcakes and a card from my family, but she was physically and emotionally exhausted. Another Christmas holiday arrived with its bone-chilling rains. My mom had passed months earlier, and her holiday wreath hung above the tent's entrance. Looking up at me, Maria asked the question that had become her standard greeting: "Do you have good news for me?"

It would take many months and even more tears before, with the help of some wonderful friends with influence, the agency handling her case was pressured into action.

I arrived at 8 am and watched as Maria nervously did some last-minute packing. She was headed for temporary housing near Chinatown. Only two garbage bags of personal belongings were allowed, so she handed me a bag of clothes and a box of plates and cups to hold on to until she got her permanent housing.

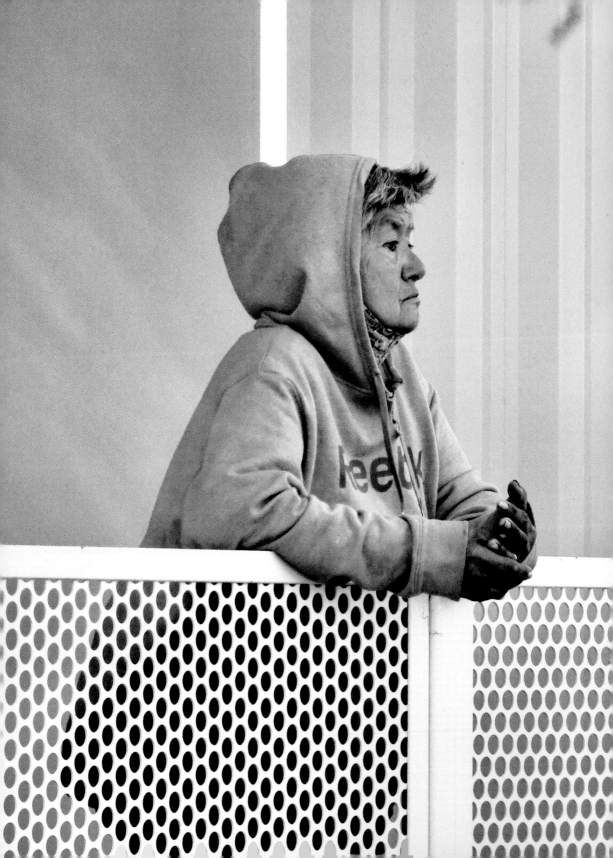

"Are you happy?" I asked once she was settled into her new transitional housing.

"Yes. I'm happy. I'm gonna make some new friends." Maria said.

Now, a year later, Maria lives in her new apartment in Hollywood.

I knew a good man who paid for his mistakes and yet found himself on the street, left to "figure it out." Unable to navigate a system meant to punish rather than restore, I watched as, without the resources to get his medicine, the voices became louder inside his head. The tent he slept in became smaller, and the walls moved closer until no room was left for the real man inside.

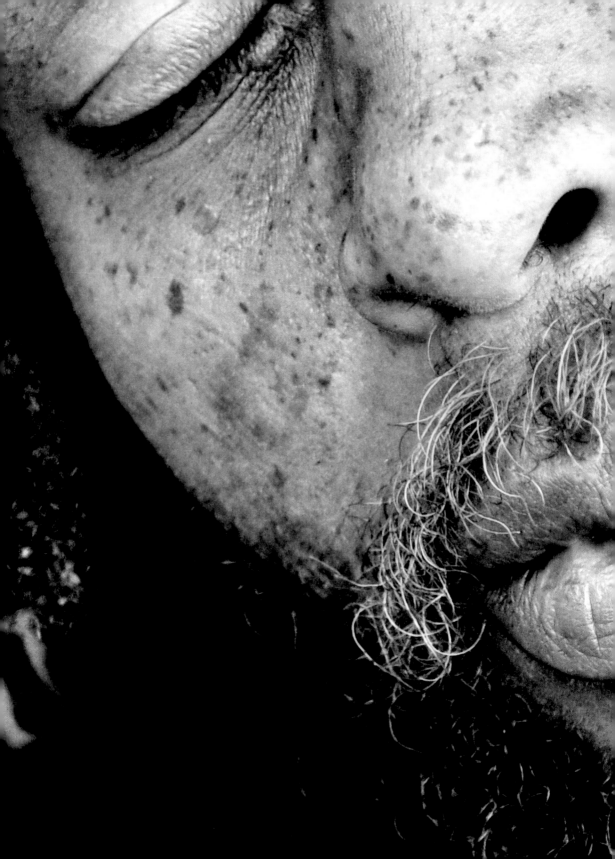

# FELIX

Every evening, when the sun goes down, Felix assembles his tent and spreads the cardboard boxes that will lay between his brittle body and the cold sidewalk. Others appear from the shadows, claiming their own piece of ground as Felix surrenders to his weariness. He was a tailor, proud of his skills and his home, but that was then.

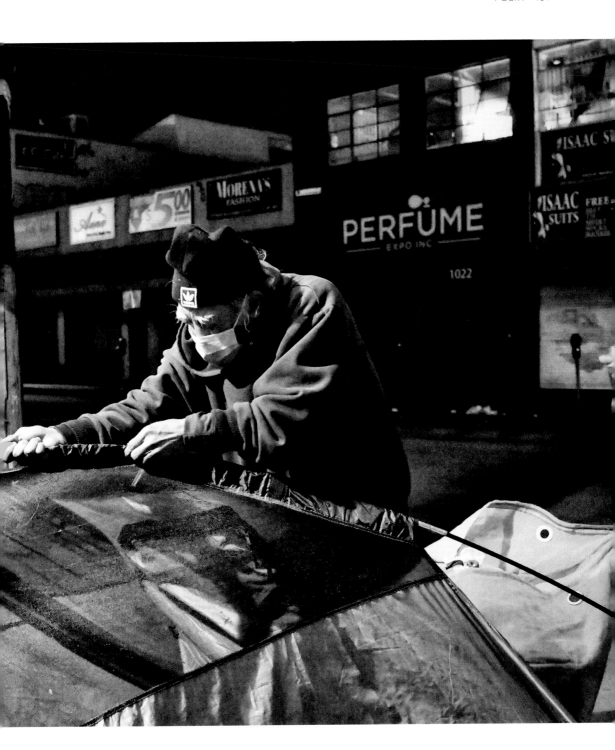

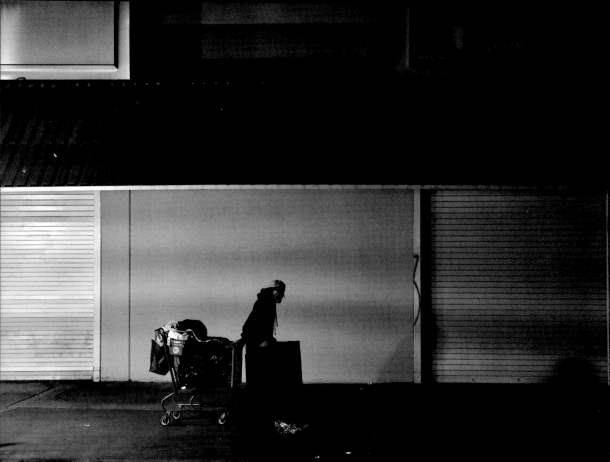

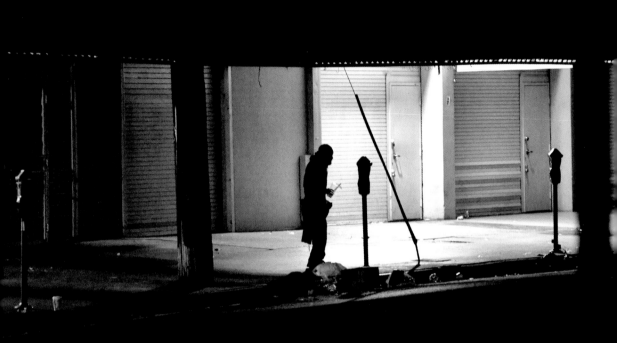

With the night comes the search for a safe place to rest.

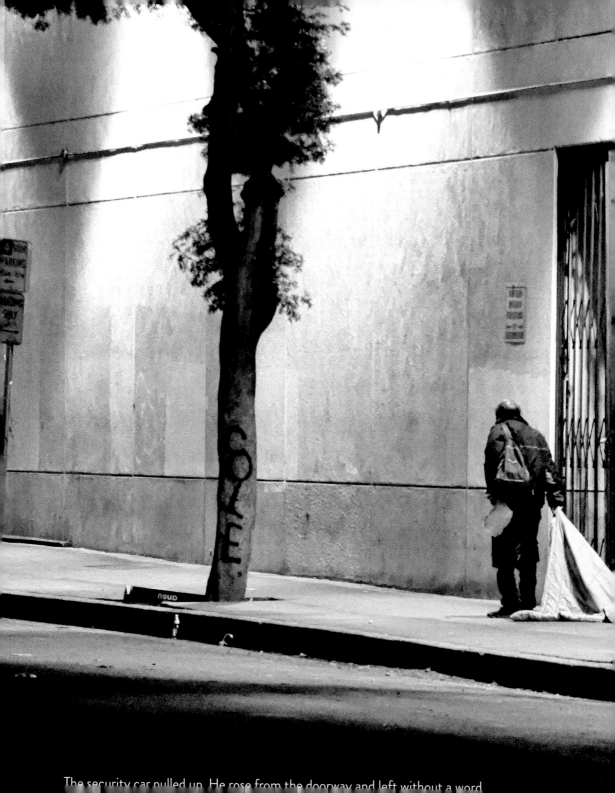

The security car pulled up. He rose from the doorway and left without a word.

# FELIPE

I sometimes saw Felipe sweeping the sidewalk as I drove past the corner encampment where several tents were planted. Sweep, adjust the tent, collect bottles and cans for recycling, and search for a meal before sunset. The routine offered a sense of normalcy to a situation that was the opposite.

On the September morning when I first introduced myself, Felipe was busy helping a friend whose tent stood nearby. He didn't say much. He never did. But he always took the time to talk to me.

On Christmas morning, we exchanged holiday wishes and a few simple clichés. The day would be like every other, he told me. But it wasn't, and we both knew it. Holidays are reminders of everything we treasure. They're also reminders of everything we've lost. Felipe would have no family chatter or children's laughter, no flashing lights on a Christmas tree, and no eggnog or turkey on a table crammed with good food and desserts. Instead, this Christmas would be spent alone.

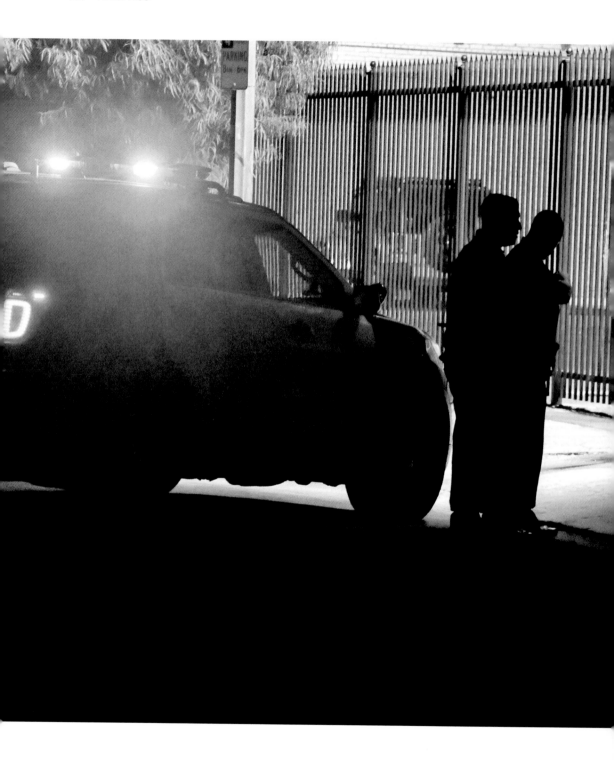

# FELICIA AND LEON

There was always a hint of sadness in Felicia's eyes, but I looked forward to visiting the RV she and Leon shared. They had been together for six years when we met and spent the last two years parked on a side street near a Los Angeles courthouse.

Like any couple, they laughed, fought, cried, and finished each other's sentences. Perhaps that's why I always considered them "Felicia and Leon." As one.

I've watched how people look at couples who live on our streets. They shake their heads while imagining what self-imposed mistakes brought them together. Have I ever had such thoughts? Probably.

It's so easy to deny someone else's need for love, especially when it doesn't look like the love we've experienced. But love changes shapes to fit our circumstances. It provides a sense of stability in an unstable existence and solace when we are inconsolable. Love can fill the empty space within us, wherever we find it.

"I was seven when I had my first drink," Felicia told me one afternoon. And since no one "made" her go to school, she stopped in seventh grade. Standing outside the RV, no smile accompanied her descriptions of childhood. No memory made her laugh. She was a child who became a young woman with little education and a scarcity of options.

"I got old enough to break away from my family, so I just told 'em I'll be back, and I left," she continued. She would eventually return to gather the children she had left behind with her sister. Was this the sadness I saw in Felicia's eyes?

Leon was proud of the classic 1968 dirt bike replica he repaired, and he sped past me, smiling. I'd never seen him so happy.

"You look like a Black Steve McQueen," I told him, pumping him up. He responded with an even bigger smile.

On this day, he wanted to share so many things that had been on his mind. He was feeling unusually optimistic and hopeful.

"I wanna get my life back on track," he said. "Man, I want to fix myself up, you know. Get my teeth fixed. You can't feel good when you look in the mirror and don't have teeth," Leon told me. He ran his tongue across his gums as if imagining his new, perfectly aligned, white teeth.

"I wasn't always like this," he continued, still propped on the bike. "I owned a bike shop, you know. So, I know all about getting permits and vendor licenses. And I was a home-care worker until I lost my job . . . that was a few years ago," he said.

Felicia had been a home-care worker too. Life had not been easy for either of them.

Leon was gang-affiliated as a teen, had done "a little time," and had gotten a second chance and a job when he came out.

"I was robbed and shot. That's when I lost my job," he explained. We stood in silence for a moment.

But this was not a day for regrets. Leon perked up and took off, speeding up and down the street, proud of his ability to repair the bike. At least for this moment, he felt that if he could do this, he could do anything.

Less than a week later, several men stood outside the RV with Leon. The men had delivered the news that a homeless man had died in a fire inside an old RV the previous night, barely a mile away. In the light of day, the charred wood, melted metal, ashes, and burnt possessions awaited a city garbage truck to carry them away. The man in the burning RV was Leon's uncle. I attended the vigil that night.

I had already met several of Felicia's eight children. They visited regularly; like any other mother, she listened to problems, gave advice, and worried about them. None who I had met had managed to rise up and out of the hardship of their childhood.

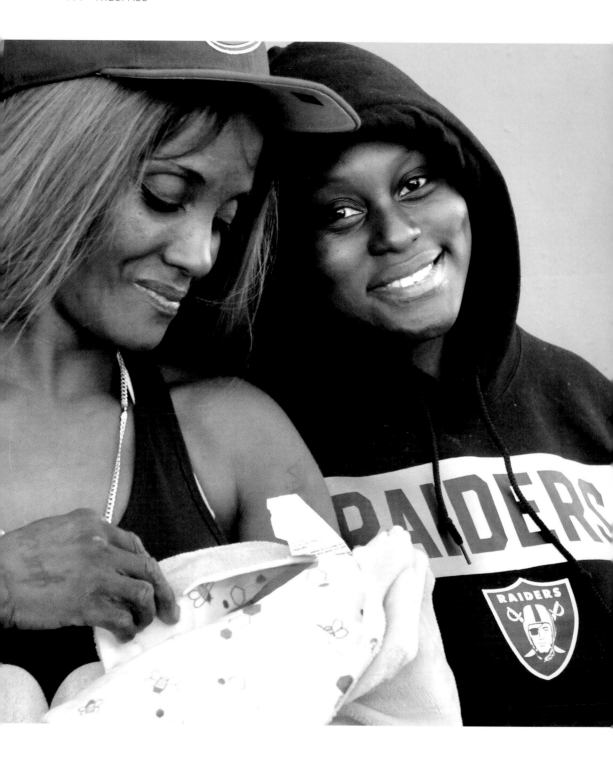

When I arrived, Felicia was cradling her beautiful new grandson, who she was meeting for the first time. Her daughter-in-law beamed, and her son stood nearby, quietly watching. Felicia just smiled and held out the baby for me to see.

The young mother, with her bright eyes and deep dimples, showered all of us with love and made everything alright. I pushed my concerns for the young family from my mind.

"He's beautiful," I said.

"Yeah," she replied without shifting her loving gaze. I could now see all the love she'd missed as a child channeled toward the baby. And for a moment, the sadness was gone.

It wasn't long after this visit that I turned onto their side street with my homemade barbecue chicken and black beans on the back seat. Ahead of me sat their torched RV with no roof or sides, and its burnt contents were strewn about the street and sidewalk.

I was just here two days ago, I thought. But two days on the street is time without guarantees. First, Crystal, then Leon's uncle, now Felicia and Leon. My mind was spinning.

I was angry, but I stood in the middle of the street with no one to tell how fucked up this was. There was no one to complain to about the many applications they submitted for housing, which never led to an interview.

"Fuck. Fuck. Fuck," I ranted while marching in circles, pining for some kind of justice and fearing the worst.

It would not be until later that I learned they had escaped the flames, shaken but unharmed, their belongings destroyed by the fire they escaped.

They were alive, safe, and gone. I would never see Felicia and Leon again.

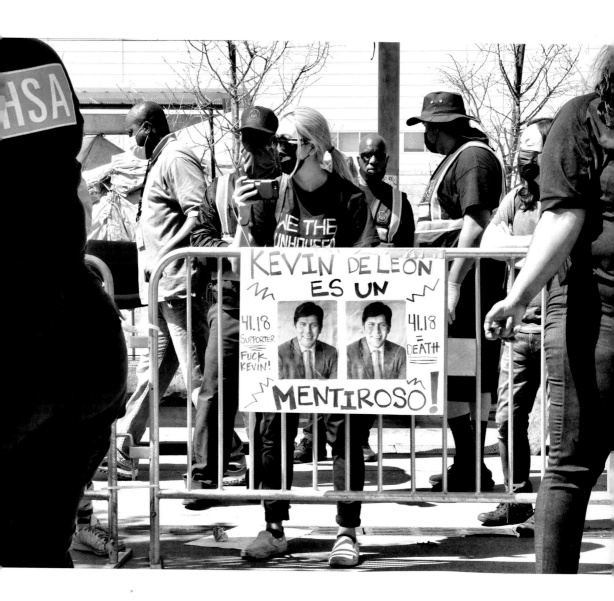

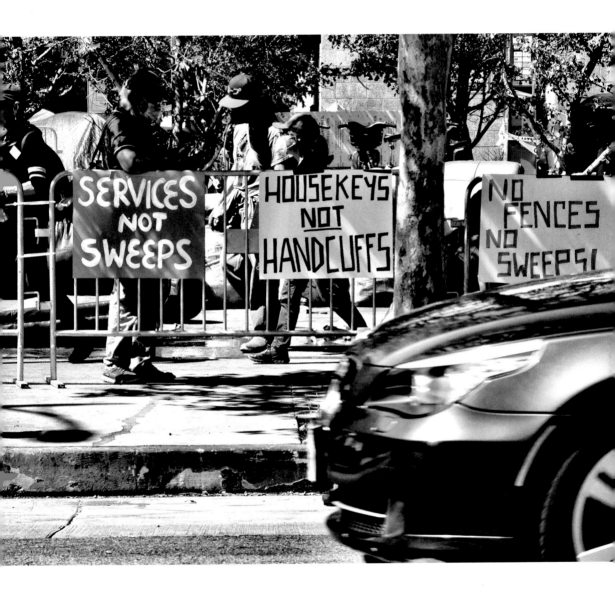

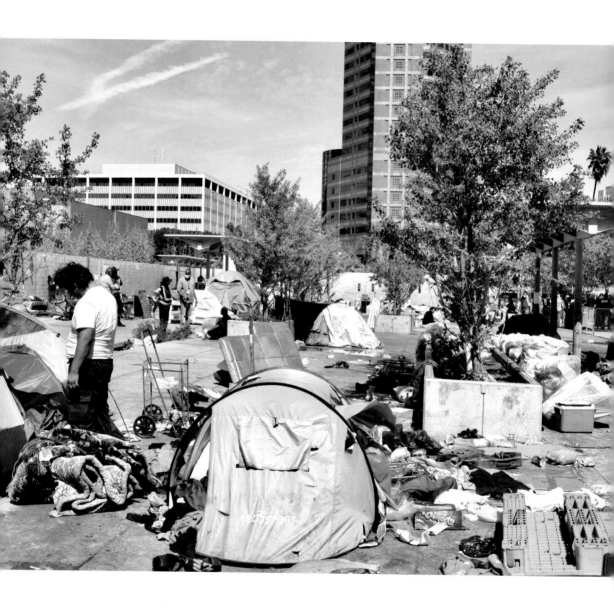

By morning, yesterday's protest is forgotten.

# DEATH

It was my first encounter. The white tent hid the body from public view, but I spied a lifeless foot that gave away the secret, so I pulled over.

The police spoke in quiet tones about their families and work. They were doing their job with no need to discuss the obvious. Death was a regular part of their daily routine, and out of necessity, the police had learned to take it in stride.

I turned to the officer in charge, a large man with a mild temperament and diplomatic air. He was from my aunt's Bronx neighborhood, and we hit it off.

"How often do you see this?" I asked.

"Anywhere from three to seven times a day," he answered.

He was weary of death and didn't try to hide it. Young, old, every color, and usually alone. He's seen it all. It takes its toll.

Violence, fires, untreated illness. And now, fentanyl deaths have increased by 1,280 percent between 2016 and 2021, totaling 1,504 dead in LA County in 2021. The numbers are overwhelming. I swallowed hard and imagined the emotional price these men and women paid.

The officer and I looked at each other like Black men often do when acknowledging a truth they both recognize. We both knew Black and brown folk are disproportionately represented among the unhoused.

Since that day, I have witnessed this scene more times than I wish to recall. The police and firefighters arrive. The tent and yellow tape go up. The coroner appears and moves slowly around the scene, eyeing the details and placing any drug paraphernalia or weapons into a plastic bag while scribbling on a yellow pad.

There is no rush or urgency. The emergency has passed, and the outcome is fatal. There is no weeping family; no whispering, vigil, or "we love you" said to assure the dying.

The coroner drove off with the body. The tent was folded up, and the police tape was torn away. One by one, the policemen drove off.

A blanket, a towel, one sneaker, and a bag of old CDs were left behind. By tomorrow those would be gone. No one would know what happened here.

The unhoused who go unclaimed are cremated and buried in a mass grave at LA County Crematory and Cemetery, a tradition started in 1896. On December 8, 2022, 1,624 unclaimed individuals who died in 2019 were laid to rest.

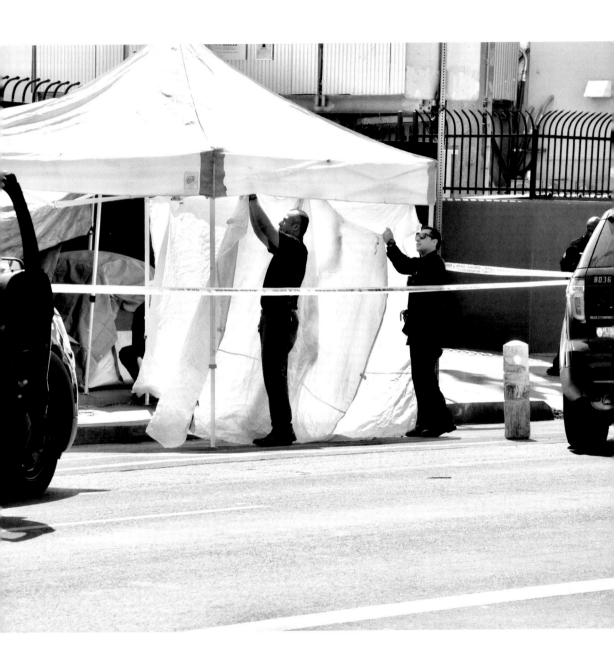

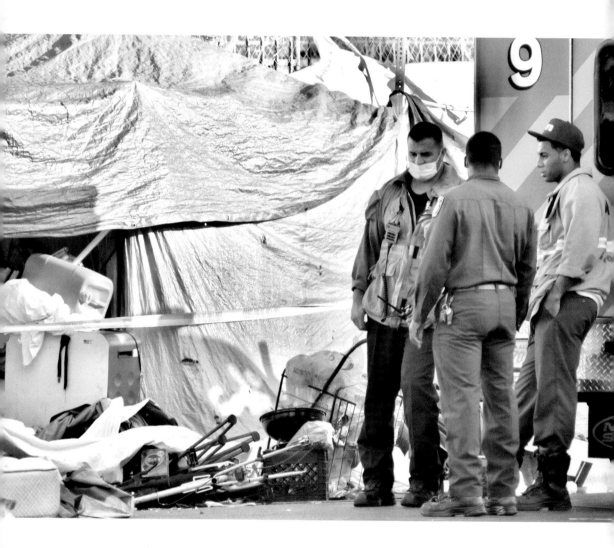

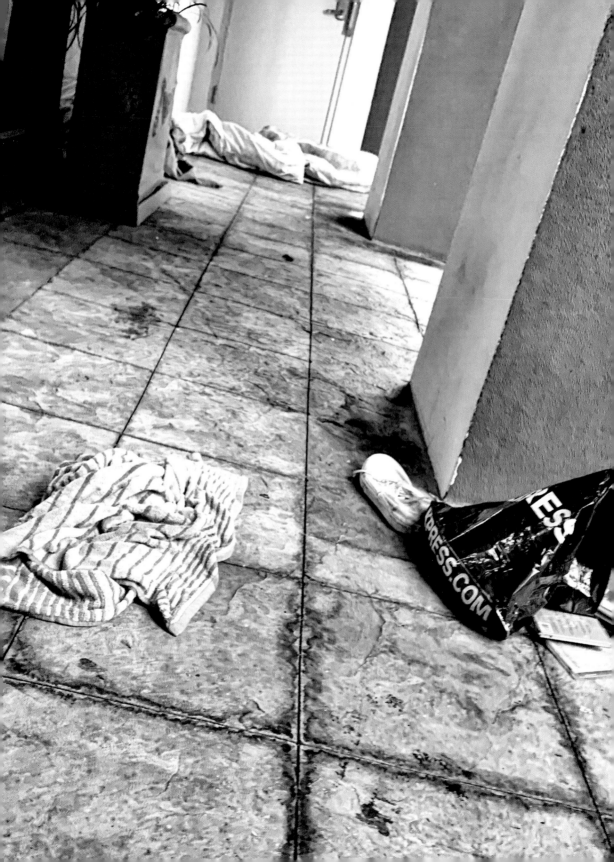

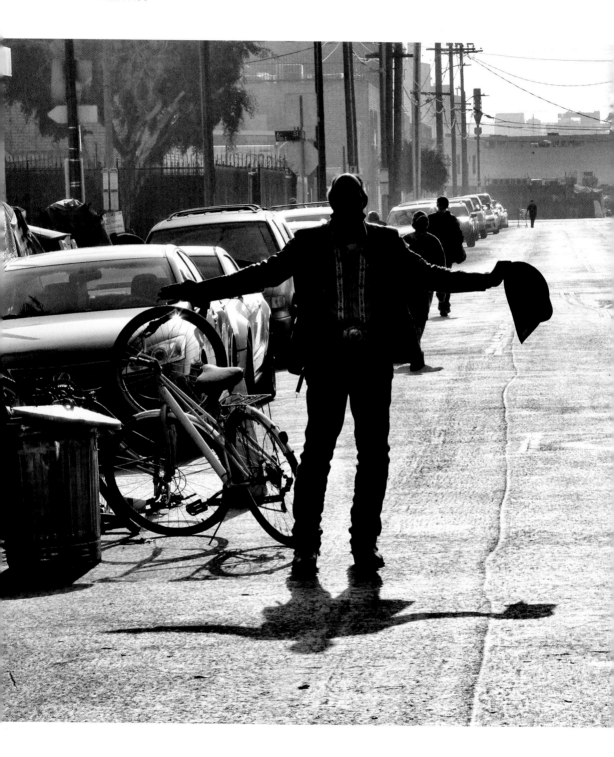

# WACO

With cowboy hat in hand, Waco danced as Michael Jackson blasted from a boom box.

He moved like a kid, his body snapping sharply into a pose with each hit of the drum.

It was a moment of freedom on a street filled with uncertainty—a freedom dance.

And when he was through, we laughed and I basked in his light.

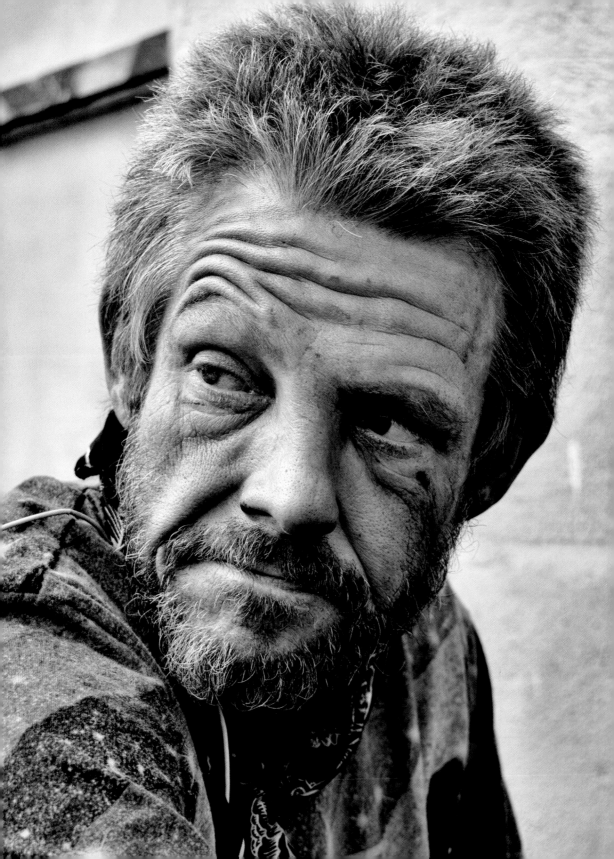

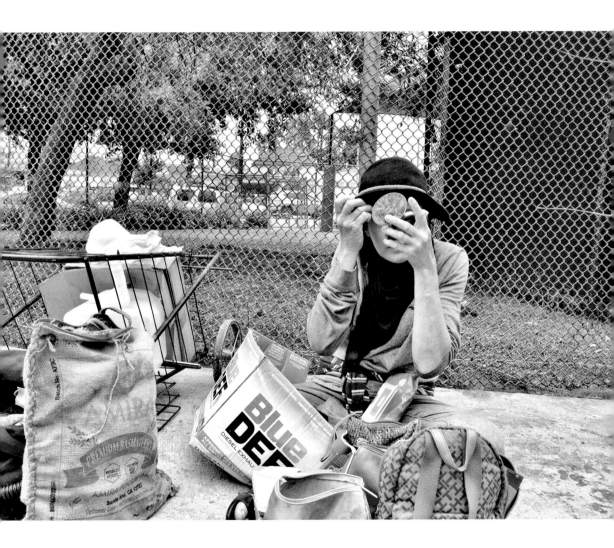

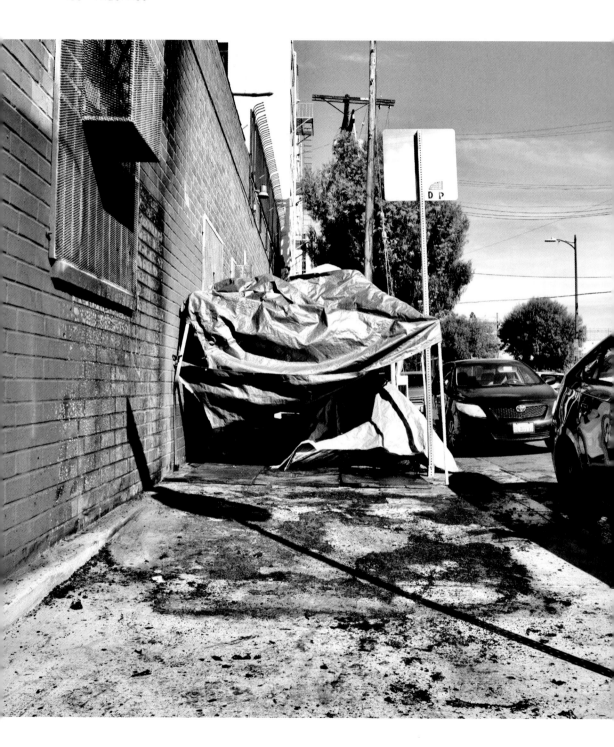

# GRACE OF GOD

"I had a dream last night that I arrived at Grace's tent, and it was gone. I spun around in place, distraught, calling into the night with no response and no chance to say goodbye," I journaled on September 25, 2022. I read it to my wife.

I look back now and remember when we met in 2021. I asked her name.

"Grace of God," she answered, seated under a large, white canopy and looking up from her book. She was Liberian, an African grandmother. Love seemed to rise from her like a mist. I knew we would be great friends and we talked of things that made us smile and laugh. A year later . . .

November 24, 2022: "Happy Thanksgiving, Grace. Hope you have a wonderful day. Is this New Jersey?" I wrote on Thanksgiving morning. She had attached an old photo of herself on Thanksgiving, standing in church with a radiant smile.

"Yes. When I had a kitchen," Grace texted back jokingly. The next day, November 25, 2022, at 1:40 am.

"My son's tent is burnt down to ashes," she texted. She always claimed the tent next to hers belonged to her son, but I'd never seen him. So I arrived as quickly as I could. Where three tents once stood, there was now only one.

Grace always felt safe. That feeling was now gone. And gone was our time laughing and talking face-to-face. Grace now stayed with a friend in Hawthorn. At least she was inside.

"I really have to leave this place after Christmas," she texted on Christmas Eve.

I didn't know why the urgency, and she wouldn't say. She said she was going "home" but never said if "home" was Liberia or New Jersey. Christmas came and went.

"Happy New Year," I wrote on New Year's morning, with fireworks across the screen.

"HAPPY AND PROSPEROUS 2023," Grace texted in return.

It was the last text of mine she ever answered.

And I thought of the dream.

# THEM FACES

I see the faces and I feel the dampness on my cheeks. I touch it, wipe it,
push and pull it, but it reappears, refusing to let me rest.

I see the faces, but they aren't on a screen. They live somewhere deep within me . . .
and they appear at their own whim.

These are the faces of those I have known over time and no longer see.

I'm overcome with missing them, for you can't be a part of someone's life, and they yours,
and not miss them when they're gone . . . can you? I can't!

I see the faces, though they aren't really there. Some have moved to new locations,
dragging tents and belongings behind.

Some have fled while their life was emptied into a sanitation truck like so much . . .
well, so much garbage.

Some, the lucky ones, have found a home.

STILL, others have perished in unthinkable ways.

I weep for the loss of all of THEM in MY life. They have given me much more
than I have given them. And they gave from the heart.

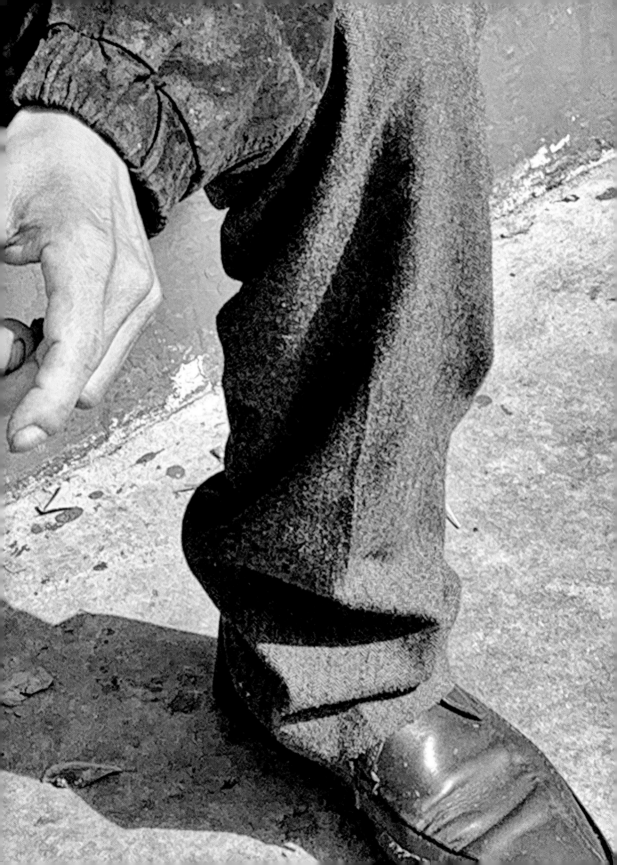

I see you

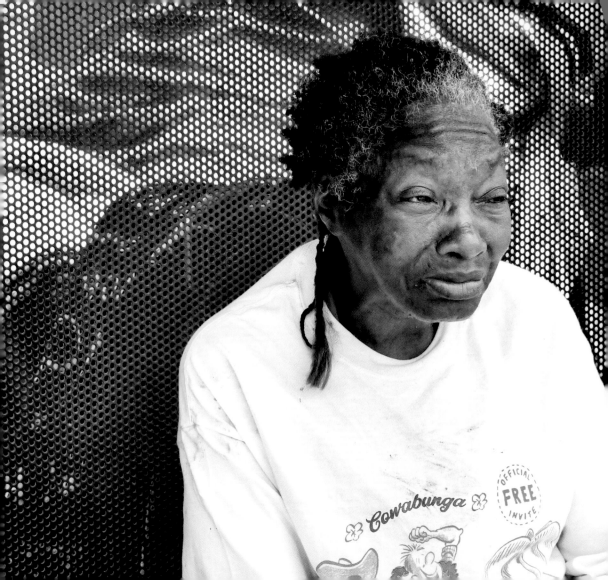

# AUNTIE

I think about our talks, and it makes me smile

I think about the tears, and I remember her pain

I think about the day I arrived and found her gone . . .

And I'm grateful that her dream has come true

I just wish we could have said goodbye

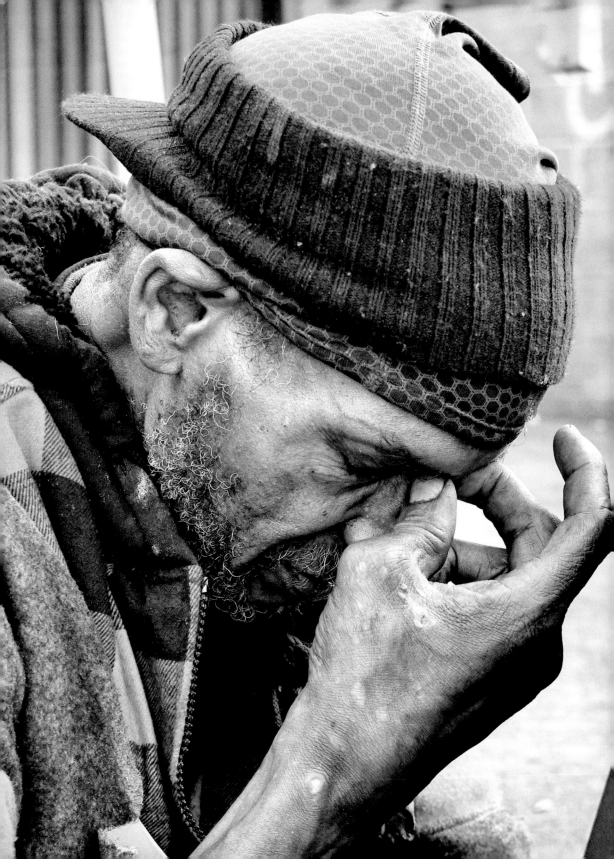

There are moments when our missteps overpower us

We are flawed—each of us, and no one is exempt

William accepted me as I accepted him . . . just as we are

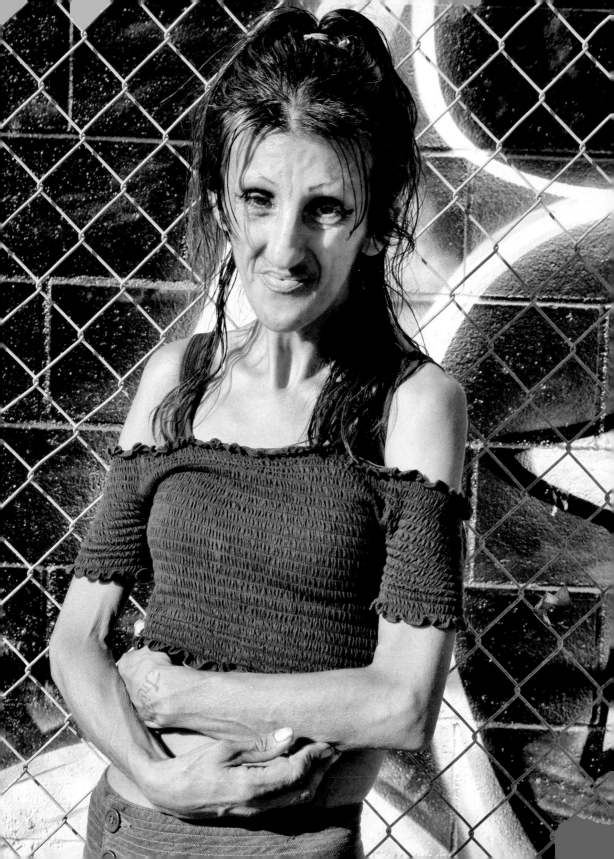

# MICHELE AND RAY-RAY

For over a year, on any given day, I could find Michele on the corner of 7th and Towne or in the nearby tent she shared with Ray-Ray. He wasn't her pimp, but he knew how she made the money she used for drugs.

Michele and I would sit on the sidewalk with our backs against the red brick wall and talk. She was the first woman to speak openly about her life on the street. Perhaps it was because when I first introduced myself she thought I was a trick, and learning that I just wanted to listen gave her an opportunity to share her truth.

Occasionally, she would ask for a few dollars to buy makeup at the local bodega. I soon learned that this was an indication that she was going to "work" and needed to spruce up her appearance.

But this day wasn't just any day. I had spent it calling hospitals and the LA Coroner's Office. Michele had been missing for two weeks, and even Ray-Ray did not know where she was. The levels of violence visited upon women living on the street provided little reason to think this would end well. But I clung desperately to hope, for to forsake it would have delivered me to the brink of despair.

Fortunately, it wasn't violence or death that had befallen Michele. Instead, she had quietly disappeared into rehab after a case worker offered a bed—immediately! This was a rarity, and she leapt at the chance to take another shot at recovery. The shot missed its mark.

Ray-Ray and Maria, who lived several tents away, eventually found out that Michele was safe. We had assumed my inquiries would eventually be met with bad news. After all, bad news always seemed just around the corner as word of overdoses, violence, illness, and fatalities spread daily from block to block.

Instead, Michele returned looking slightly healthier despite still weighing under ninety pounds. But checking herself out of rehab prematurely left her with a gloomy air of disappointment.

It was like a cruel Groundhog's Day joke. Return to the same faces, places, and things you were running from, which also meant a return to the same old habits. In Michele, I could see the unrelenting chokehold that addiction can have. How could anyone succeed, I wondered, when three months of rehab would only land you back where you started?

"I'm doing real good," she told me when we caught up. But her words, laced with resignation, only scratched the surface of her regret.

"I talked to my sons. I want to see them," she said, trying to cheer herself up with her favorite subject. They had been apart for years, and Michele's father had refused her any visitation. So the occasional phone call was the best she could hope for.

"The youngest is still in middle school, and the other one works at Staples," she bragged. "I think he's a manager. He's got a girlfriend," she continued.

The thought of her sons brought a smile. I've met mothers whose children have been left with relatives or ended up in the foster care system. But I've never met a mother whose heart wasn't broken by it and who didn't long to reunite with them. Though they were destitute or living in horrific conditions, or struggling with addiction and the trauma that comes with it, their situation never quelled the longing to be the parent their children deserved.

The cycle continued. Hospital stays, failed rehab, a slow recovery, and back to the same streets she was trying to leave behind. Michele's father died, but no one wanted her at the service. She was told he left her a little money, but that never appeared either. Life's disappointments seemed endless. She got housing but lost it.

It's been months since I've seen Michele. "I ain't seen her," Ray-Ray told me.

Ray-Ray was no saint and told me of his own disappearances after getting some pocket money. From Chicago, he had been a pimp and a player years earlier. At least that's what the streets said. But I had watched him give Michele her daily medicines, feed her, and wheel her to the showers when she was too weak to walk. They fussed and argued, but there was a connection, not romantic but caring, and probably some codependence as well. He pulled her

out of hospice literally, where she would have surely have died and should have never been in the first place

A month earlier, he told me that he wasn't taking the studio apartment being offered by the Veterans Administration until Michele's housing was set up. Now, he was in the tent alone, she was nowhere to be found, and he moved forward.

"My daughter," he said smiling, "I saw her today. She was five when I left and seventeen when I came back," he shook his head at the thought of his years in prison. "So I got to know her when I got out. Got a good relationship with her," he said.

Fathers, even those who've missed pivotal years in their children's lives, still pray for their success.

"She's a nurse practitioner, delivers babies . . . she's doing really good," he said in a deep, raspy voice filled with pride.

"I think, as long as I'm in the city, I'm gonna be connected to the shit down here. I mean, this is my community. This is my hood right here," Ray-Ray told me on this sunny afternoon.

We were surrounded by the homeless, but he found friendship and community here. People wonder why some homeless choose to remain on the street rather than go to shelters, or apartments or motels in unfamiliar neighborhoods when offered the chance. For many, after so many years, it is the only community they know, and leaving it is harder than we can imagine.

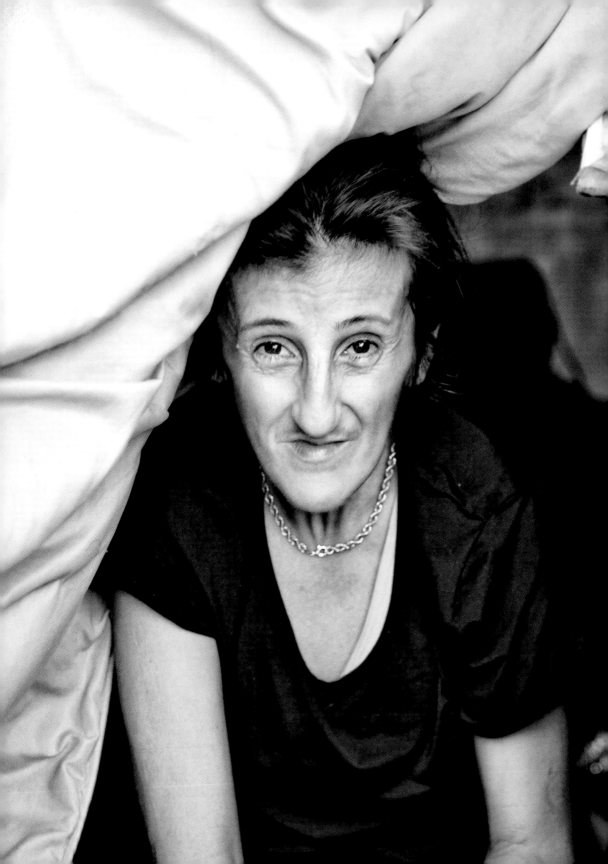

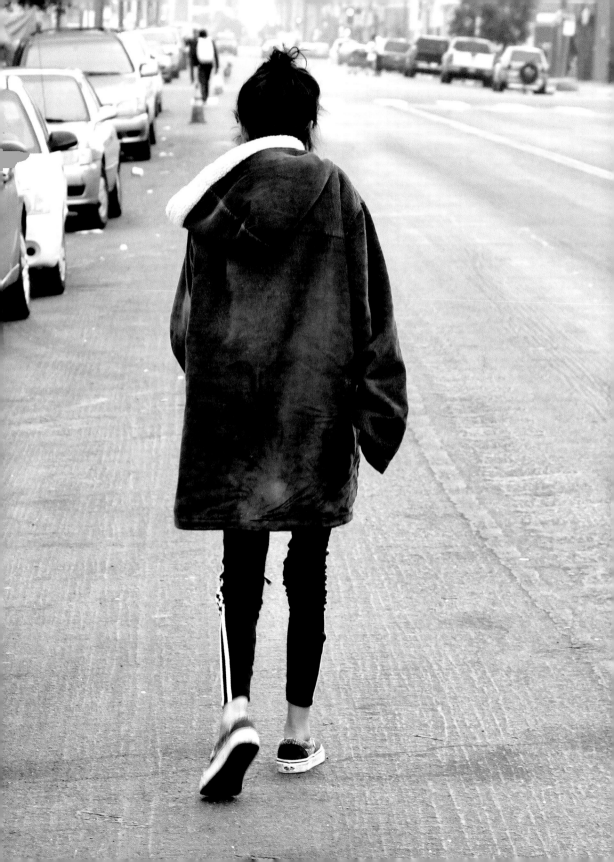

Ray-Ray moved into his new apartment only blocks away from his tent. That same day, he received word of his mother's passing, in Chicago. His daughter and ex-wife helped him pick out the flowers he sent.

I did not suspect that the day we spent together taking these pictures, laughing, and talking about family would be our last time. A short time later the drug that was taking lives all around us finally took Ray-Ray's . . . fentanyl.

*"Albert fly high with the angels you are being missed we love you son"*

Every day, parents search the streets for their children and leave messages of love behind.

# BRANDON

He said he had stories to tell. I held up my hand in a "just one-minute" gesture and returned to Juicy, whom I was interviewing. But a one-minute wait was a minute too long for Brandon. He was bursting with emotions, observations, and life's hard-learned lessons, which he shared in a stream-of-consciousness rant that I could not ignore.

"What do you miss?" I asked, referring to his life BSR, Before Skid Row.

Brandon's eyes dropped to the ground, and he gave the question his most serious consideration.

"I miss," he said, resting his face in his hand with a deep sigh . . . "me," he finally answered softly.

There was so much honesty in his answer that I could not speak. Though he did not say it, Brandon feared that part of who he was, perhaps the best part, had vanished forever.

He had a way of speaking that made me lean in. With his eyes closed, he thought long and hard before diving fearlessly into his very personal revelations.

Drugs? Yes. Sexual orientation? Unabashedly bisexual. Childhood? Sexually abused by a family friend and witness to his father's brutality toward his mother, Brandon was simultaneously fragile and powerful.

"It is what it is," he seemed to say with a dismissive shrug when speaking of the abuse. But then Brandon's head would drop, and he would lose himself in a memory that a shrug of the shoulders could not erase.

"What do I need to get off the Row? An epiphany or a straight calling (from God)," he said.

But epiphanies don't grow on trees, and God . . . well, God seemed a little hard to find at the moment. And I realized that the mystic interventions Brandon sought placed control of his life in someone else's hands. Maybe what he wanted most was to relinquish control and know that everything would turn out OK.

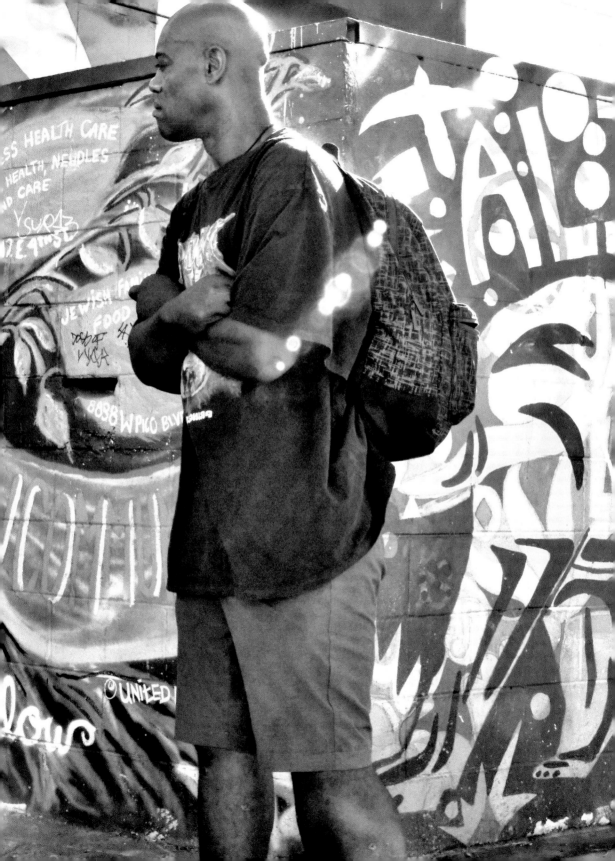

We talked, or I should say Brandon talked, and I listened. He spoke eloquently about his life and those he left behind in Cincinnati.

"Believe it or not, I was a salary manager for McDonald's, ladies and gentlemen. Amen. I said that because that's the responsibility, and because of where I'm at right now, it's like, wow. But along the way, ladies and gentlemen, I know now I was scared of success. I was a little nervous."

His "general anxieties" are real.

"That is a fear, ladies and gentlemen. If I'm going to Six Flags tomorrow, I might think the tire will bust before I get there. I also have depression. I try not to be depressed, but I get depressed," he confessed.

Brandon's mental health challenges impact every aspect of his life and have been treated through his self-medicating. Still, he possesses a spirit of giving.

"The spirit does touch me every single day that I live. Because if you wake me up in the morning, it is my due diligence to take care of somebody," he said.

Then, suddenly, as if putting an exclamation point on everything that had been said, he looked me in the eye.

"If you can't help somebody, at least be nice. That might just change somebody's life," he said.

It was so simple. It was so clear.

"That's why you speak to people," Brandon explained. "Hi, how you doing? Fine, thank you," he said, imitating two strangers meeting.

His voice quivered. He knew firsthand the hurt and disappointment that comes with being invisible.

"The normality of a conversation might help somebody. People cry when they don't get spoken to 'cause nobody sees how they was doing," he concluded.

And then he stopped.

"I want to do what I want to do, but damn, I want to do it the right fuckin' way, brah," he said.

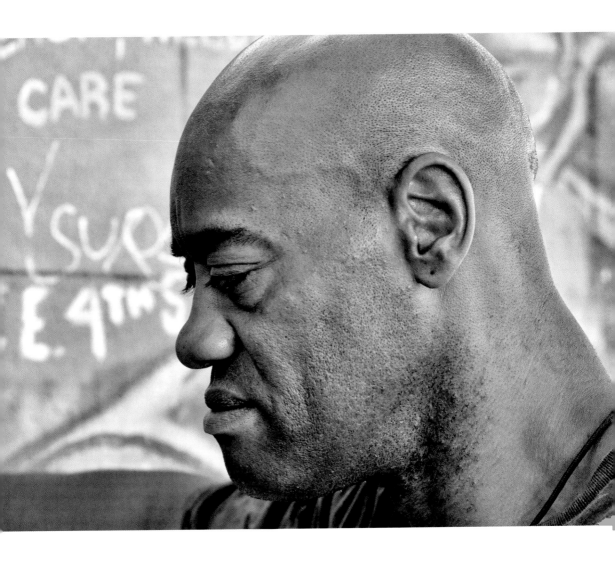

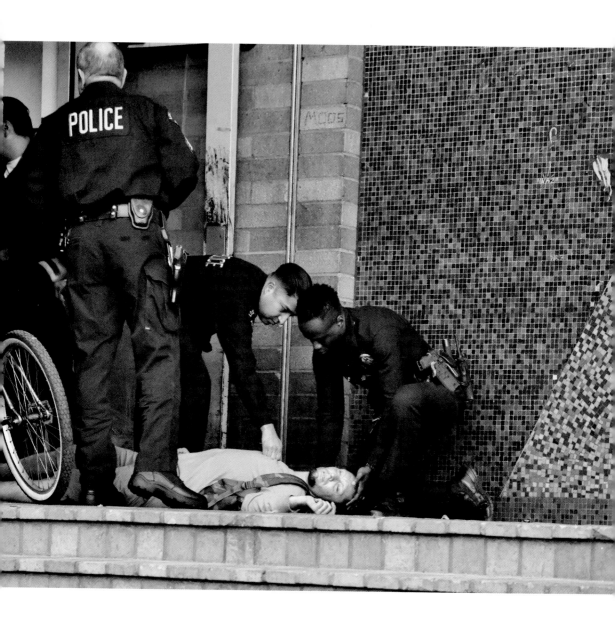

I slowed at a red light in front of the police station as a lifeless body was deposited by a faceless stranger outside the station house doors. I had witnessed this before on this very corner beneath the sign that read "POLICE" in big, bold letters.

I am left wondering how we allowed things to get so out of hand—seemingly on the road with no return, where the addicted have one methadone clinic for veterans only (methadone helps manage fentanyl addiction) in all of downtown LA. Or, the unhoused are returned to the streets they ran to rehab to escape—returned to the same faces, places, and drugs they desperately wanted to avoid.

When did we take our eyes off the children who needed us, and who, now grown and on their own, struggle to fill the void with opioids?

Or the women and men who've watched the rents go up as their salaries went down, until finally there's nowhere else to go but a car or a tent?

Years of intentional neglect have landed us in a pit of despair and addiction, and it will take years of intention and compassion to claw our way out. But we must rise to the task.

The EMTs arrived, Narcan was quickly administered, and the man who was dying moments earlier survived and walked away. This time.

# BOBBY

Bobby was no stranger—I'd seen him often from a distance. We moved down the street side-by-side, talking of his years at Exxon Mobile. "I'm a bookkeeper," he told me, rattling off his many years of work experience. The person we become can be very different than the person we used to be.

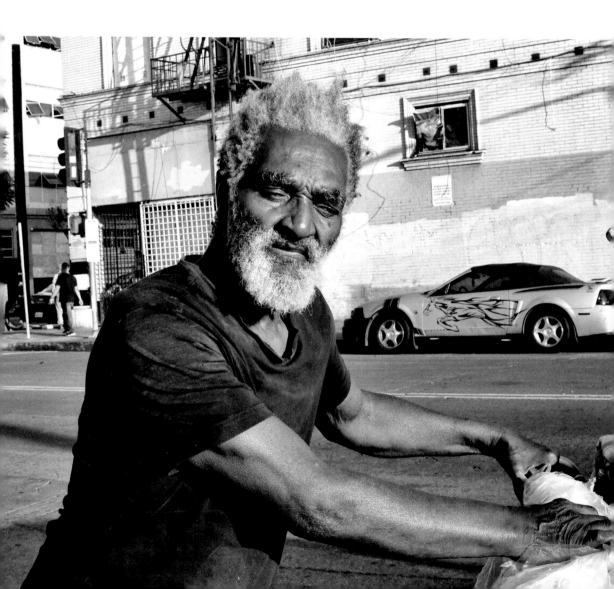

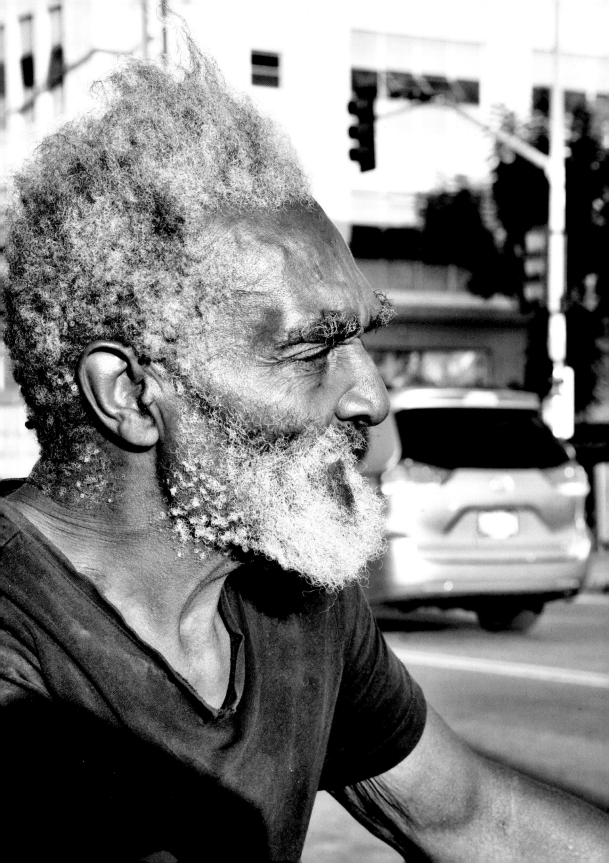

Whispered words linger a lifetime . . .

poor

worthless

dirty

no good

None of these hurtful words are true, but

how is a child to make sense of it?

Sometimes I look at the faces I've photographed—the people I've met—the stories I've heard, and a wave of melancholy drapes over me like a blanket.

If a man ain't supposed to cry, then I'm fucked.

But I dare not stop or turn away . . . to do so would be to deny the undeniable.

The faces I see are me! They are embedded in my memory as I look for the strength to speak of something I long to forget. The suffering. Not my suffering.

I've not suffered—not really.

I'm speaking of real suffering. The suffering of a family sleeping in a dilapidated car and waiting months for housing.

The suffering of a seventy-year-old woman sitting inside a tent as the rats scurry past.

Or the youngster who has aged out of the foster care system without a job or somewhere to sleep.

I surrender

The baker

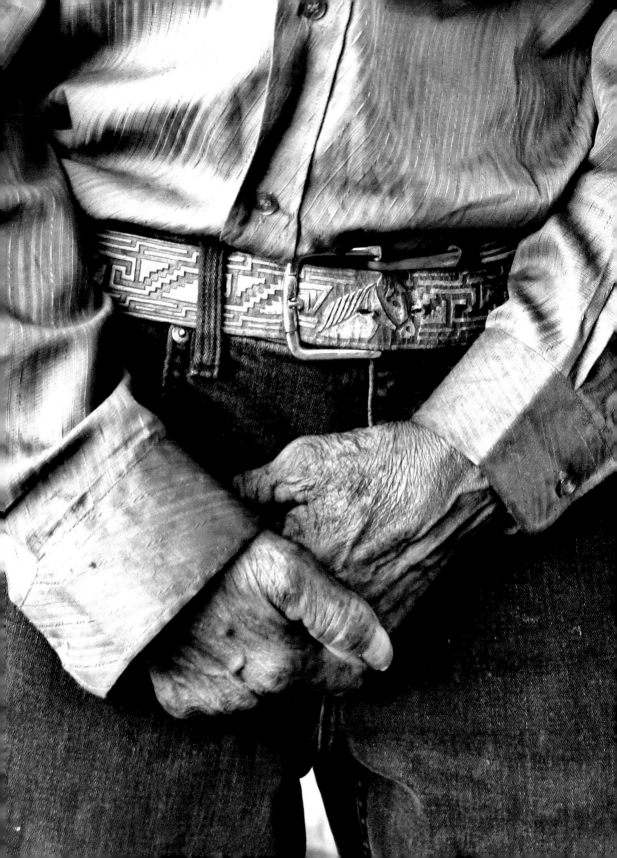

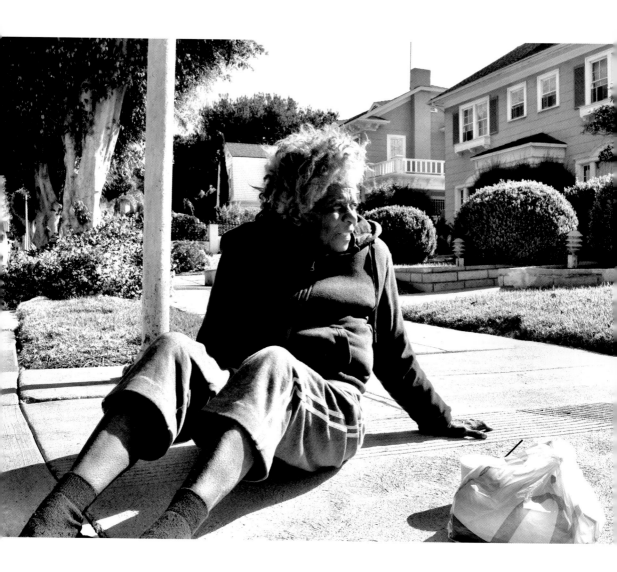

# BRENDA

"If I'm not here, just sit down and wait," Brenda once told me, pointing to the sitting area she recently constructed outside her tent. Brenda enjoyed having visitors, but disagreements with her sidewalk neighbors led to her sudden departure, ending our weekly chats. She was gone.

Months later, on a beautiful April day seven miles from downtown, I turned a corner and spotted Brenda's trademark orange mane, now longer and stretching in all directions. I swerved to a stop and jumped from the car, calling her name and rushing to plop down on the sidewalk beside her. Her laughter and smile were as animated as always.

"I don't have to worry here," she said as she surveyed the homes around her. "Nobody's walking down the street yelling and screaming," she explained.

An older woman stepped from her house, spotted us, and joined the conversation as if this were an everyday occurrence. She spoke of her grandchildren affectionately, as if we were old friends getting a family update, then she smiled, waved, and left us sitting in the sun.

The woman addressed Brenda with tenderness, not judgment, and she was a welcome reminder that people can be kind.

Brenda has vanished again, but I still drive through neighborhoods with eyes darting side to side, hoping that she's found more permanent accommodations.

I sat across the street, watching as men pushing shopping carts and women pulling tattered suitcases looked through the bars and requested the junk food inside. Or sold their food stamps if the cold or the rain forced them to get a cheap motel room. The gates never open, and customers never enter. There are no fruits or vegetables, or full-service grocery stores in sight.

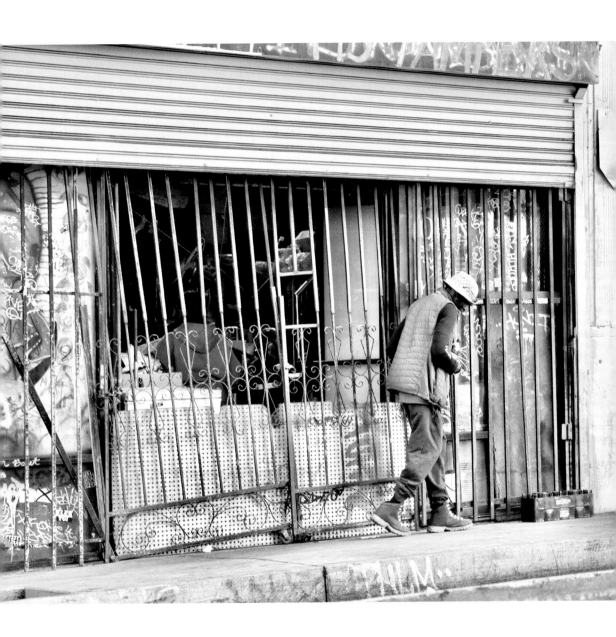

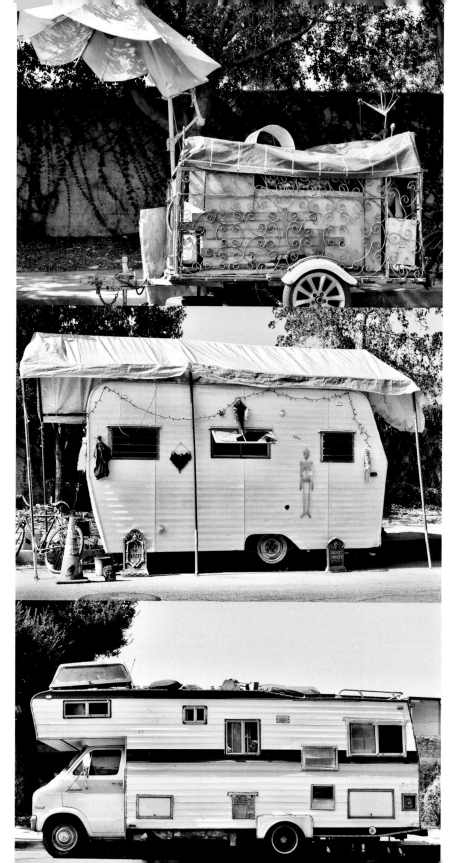

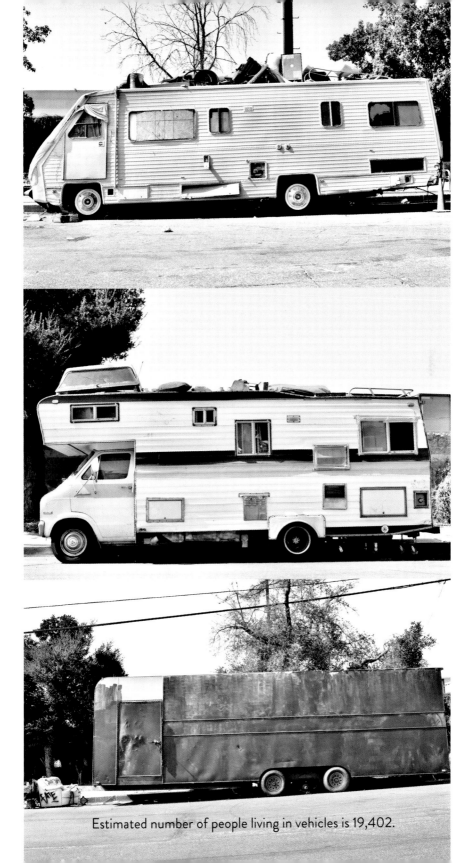

Estimated number of people living in vehicles is 19,402.

# HEROES

It is easy to feel that nothing changes no matter how much one tries to "make a differ-ence." However, change comes slowly, often imperceptibly, and we must honor those that are committed to making that change happen.

For some, it is a spiritual mission. For others, it's a career. For many with no religious affiliation, it is merely because we are all human, and it is the right thing to do. But for everyone they touch, the impact is undeniable. These are the heroes who take their love and compassion to the streets, and they do make a difference.

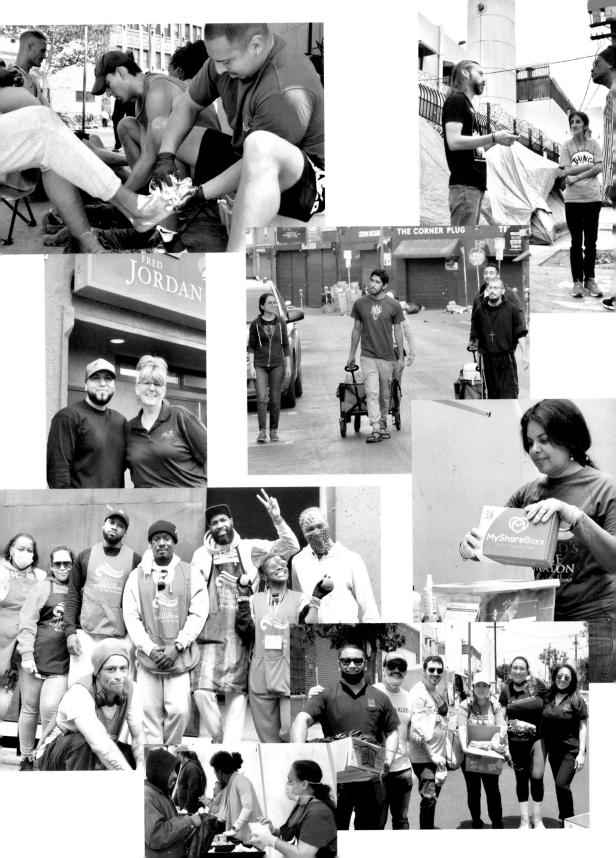

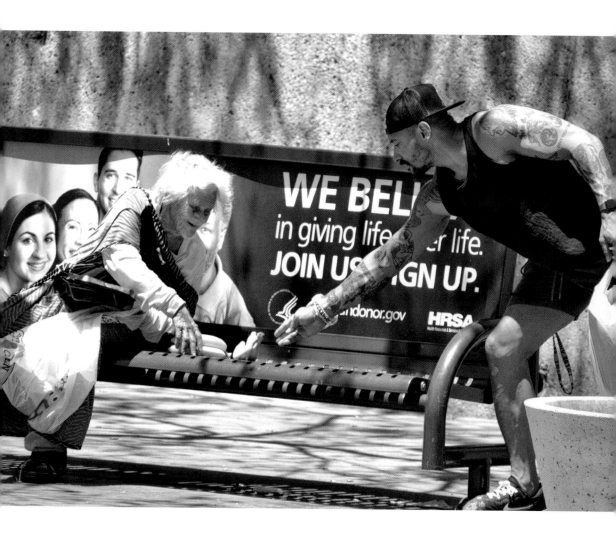

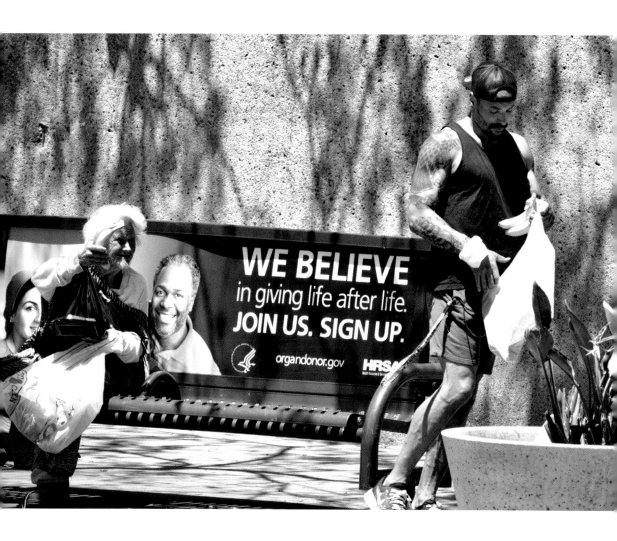

# A PIPELINE TO THE STREET

Apipeline leads from the American Dream to our streets, and the spigot is wide open. Poverty, mental illness, drugs, trauma, lack of education, and decades-old societal and economic inequities are among the various factors that have left many of our families and neighbors desperate for relief, which appears elusive. Of course, there is enough blame to go around among our various political parties and profiteering interests, as evidenced in redlining and dubious housing policies dating back to Los Angeles's beginnings. However, it is my hope that current California office holders, with authentic commitments, will succeed where others have failed. Remember, photo ops and rhetoric do not a solution make.

We must be vigilant and stop the callous discard and mythology surrounding our unhoused, as captured in the words of Ronald Regan, who stated in 1984 on Good Morning America, "One problem that we've had, even in the best of times, is the people who are sleeping on the grates. The homeless, who are homeless, you might say, by choice."

I've even heard contemporary versions of these sentiments repeated from the floors of Congress when stimulus money was distributed that lifted children out of poverty and helped families stave off eviction, if only for a little while.

But we the people have also played a role in today's conditions through our silence and inertia. For too long, we have turned away, ignored, and stepped over those who need us most until now, when we can ignore them no more, for they have arrived at our doorsteps.

Only when our collective compassion and empathy replace disgust and judgment will we recognize our shared humanity and fight for change. Until then, the pipeline will remain open, pouring more unhoused onto the streets faster than we can house them.

# THERE IS STRENGTH IN THE HUMAN SPIRIT

How do they do it? This is the question I continually ask myself as I spend time with the unhoused on the streets of Los Angeles. They are damaged, ravaged, and beaten down by the cards life has dealt them, or the cards they have admittedly dealt themselves, but somehow they make it through another day. There is strength in the human spirit of those who find a way to survive. It is this strength and our shared humanity that bring me back and make me proud to call many of them my friends.

I can't help but imagine how their lives might have been different had the strength and determination that I see been harnessed and redirected. Where would they be if their own damaged parents had been guided with love? What would their futures have looked like if the government had not been complicit in introducing new and more addictive drugs into communities of color and among those who live in our rural outposts? How would their world have been changed if mental illness had not wrapped its unforgiving arms around them?

Our society would be a different place if justice didn't equal Just Us and treatment for addiction and mental illness had not lost out to mass incarceration. Imagine if we spent as much on the needs and wellbeing of our citizens as we do on the tools of war.

I have heard the stories and seen the scars, emotional and physical, borne by the homeless. I've witnessed how years of childhood abuse can easily roll into adult relationships of dysfunction and more pain than one can stand. And I know how untreated addiction and mental illness can lead down a path with little chance of return. I believe that we are the product of the love we receive. Absent a hand to hold, an ear to hear our pleas, or a way to realize that dreams actually can come true, there is great danger of falling into hopelessness.

The exponential growth of the unhoused is not a new phenomenon but rather it is the result of years of assault on policies that once helped the nation's marginalized citizens find food, shelter, and opportunity.

We step over them like roadkill, avoiding the stench and their glazed-over eyes. We roll up our windows when their cup, jingling with coins, approaches. It makes us feel safe to separate ourselves. But the streets are filled with people who were once like you and I. The vast majority are good people, many of whom lived on the brink of poverty despite a forty-hour workweek. Others were professionals with thriving careers who were derailed by mental illness. These are the people who now reside on our sidewalks, under our bridges, and inside disabled RVs parked on the side streets of our country. The unexpected is the great equalizer.

Only when we raise our standard of education for all, deliver emotional support for all families and children, provide addiction and mental health services for all, supply jobs and other avenues for uplift, and provide our unhoused with the tools for a healthy reentry to society—only then will we start to shut down the pipeline that leads to the street. Until then, a high-rise built for the homeless is merely a political photo op and the building of another ghetto. Love, compassion, and funding, when paired with comprehensive solutions and action, can provide a path to change.

I hope the people in this book and their stories have touched your heart, just as they have touched mine.

# ACKNOWLEDGMENTS

There are many people who have made *Trespass* possible, and though I have surely missed a few here, I thank you all for your commitment and contributions.

Thank you, Jenifer. You're an amazing wife who packed meals with me, helped me through some highly emotional moments, and always fueled my passion with your love. Without you, I could not have seen this project through to its completion. Thank you, Honey—you are the best partner I could have hoped for.

Hunter, you have taught me many things over the years, and your loving smile and dedication to your dreams have given me strength and purpose. I hope you have learned as much from me as I have from you. *Trespass* is for you, my son.

This book, and indeed my life as a creative being, would not have been possible without the unconditional love of my parents and grandparents. They taught me that nothing is more important than our love for each other and for those who have been denied it. It is their shoulders upon which I stand and their talents that inform my work. And a special mention for my "Uncle Don," whose talent as an artist, photographer, and writer will always propel me forward.

To my sister, nieces, great nieces and nephews, aunties, uncles, and cousins, you're a constant source of joy and encouragement. Harlem is in our blood. Laughter and love sustain us, and we are forever bound together. Thanks to you all.

No creative endeavor exists in a vacuum, and I have been supported throughout this project by a team of brilliant friends. They are family. Melinda Nugent, thank you for suggesting I present this work to the world and helping me start that process. Natalie Hill, you've helped me bring my visions to fruition for more years than I can divulge. You always find a way to get the job done, and I love you for it. Nancy Berglass, somehow you turn my intent into thoughtful strategies that guide me toward success. Jennifer Gross, you've given to the unhoused community for years, and I thank you for sharing your resources, skills, and heart with me. Barbara Bestor, thanks for giving *Trespass* its first exhibition and enabling me to bring my photographs to hundreds of caring individuals. Karen Lee, Jacqui Thompson, and Brent Hamlet, your phone calls and ideas continue to provide new avenues of engagement for *Trespass*, and I appreciate each of you. Salim Akil, you continually encourage me to push my art further than even I might have imagined. Thank you, brother. And Christopher Smith, the launch of this book is not the same without you. The laughter, insights, parenting tips, and

good wine we have shared through the years brought joy that cannot be measured. You will forever be missed my brother.

Maribel Marin, Melisa Chavez, Ricky Bluthenthal, Skipp Townsend, Casey Penn, and Bill Bedrossian, you have dedicated your lives to helping others and have done your best, sometimes against insurmountable odds, to get them the services and the housing they need. Thank you for your friendship and your support. And to all of my friends and neighbors who have dropped off clothing and food through the years, you have truly made a difference.

Liz Nealon, you called with an idea to turn my photos and writings into a book. What can I say? You are a great agent and friend; without you, there would be no book. Appreciate you.

Special thanks to Avion Ruth, for his commitment to the needs of others and his invaluable research for *Trespass*. A bright light shines on you.

To the Broadleaf Books team, and especially my extremely talented editor, Jarrod Harrison. Your commitment to excellence and socially significant work has made this collaboration a pleasure.

Special thanks to my partners at 2nd Call, Covenant House, and Velnonart.

And most importantly, I would like to acknowledge the people who have shared their stories with me. Some have become friends, and all have made my life richer. Thank you for allowing me to bring your stories from the shadows and into the light.

Al; Dadisi; Maria; Crystal; Gardner; LaToyee and her wonderful daughters; Auntie; Ray-Ray; Michele; Eric; Brianna; and Naveya . . . there would be no *Trespass* without you, and my deepest hope is that your journey gets easier and is filled with the love, support, and success you deserve.

What started years ago as a personal connection with a few unhoused friends in my neighborhood became a mission to reveal the true depth of their character and the range of their experiences. It has not been easy emotionally, logistically, or even financially, but whatever challenges I have encountered are insignificant compared to the hardships faced by the women, men, and children you see here, and the tens of thousands more who remain unseen and unheard on the streets of our nation.

# ABOUT THE AUTHOR

As a writer, director, and multi-dimensional artist with decades of experience, Kim Watson has written, filmed, and photographed subjects ranging from the iconic entertainers of our time to the "invisible" people of marginalized communities.

A highly influential director in music videos' early days, Watson has directed Grammy winners, shot in uniquely remote locations, and written across genres that include advertising; feature films for Hollywood studios such as Universal, MTV Films, and Warner Brothers; and publishers Simon & Schuster and now Broadleaf Books.

His passionate marriage of art and social justice has been a lifelong endeavor, and after more than four years and hundreds of hours spent photographing and talking to the homeless, he is ready to unveil *Trespass: Portraits of Unhoused Life, Love, and Understanding*. His unusual sensitivity has led the unhoused to welcome him into their lives, as he has welcomed them into his heart.

TO  SEE OR ORDER SELECTED LIMITED EDITION PRINTS
AND FOR A FULL PHOTO INDEX, GO TO

https://www.kimwatsonart.net/trespass

A PORTION  OF ALL PROCEEDES FROM  PHOTOS GOES TO
TRESPASS PARTNERS

trespassamericaproject@gmail.com

YouTube: @trespassamericaproject

IG @KIMWATSONART

GUILD AFFILIATIONS

Writers Guild of America West Los Angeles, California, Lambda Pi Eta, National Communi-
cation Association Honor Society and The Authors Guild.

# LA COUNTY FACTS AT A GLANCE

## Vehicle Dwelling

According to the Los Angeles Homeless Services Authority (LAHSA) 2022 homeless count:[1]

- 69,144 people were experiencing homelessness in LA County.
- The number of people living in vehicles (cars, RVs, and vans) in Los Angeles County is 19,402.
- There's been a 17 percent increase in tents, vehicles, and makeshift shelters on LA County's streets and sidewalks.

## Substance Abuse, Mental Illness, and Mortality

- There are an average of about five deaths a day in LA County (most recent data year following COVID-19).
- Nearly 1,500 unhoused people are estimated to have died on the streets of Los Angeles during the pandemic (March 2020–July 2021)
- 542 died on the sidewalk, 85 died in alleys, 197 died in parking lots, and 84 died in tents, according to data from the county coroner.[2]
- According to UCLA, 50 percent of unsheltered people reported that they suffer from a combination of a physical health condition, a mental health issue, and a substance abuse condition (2019).[3]
- According to the LA County Dept. of Health, more than 2,000 unhoused people died from fentanyl overdoses in 2021, and more people experiencing homelessness died of overdoses in 2020 and 2021 than in the six previous years combined.[4]

## Budget and Spending

Between 2015 and 2020, millions in grants and funding for housing and to address homelessness have gone unspent.[5]

- About $150 million worth of federal grants from the Department of Housing and Urban Development (HUD) went unspent between 2015 and 2020.
- The HUD was awarded $133.1 million in 2020.
- LAHSA returned more than $29 million to the HUD during the five-year period.
- The Housing Authority of the City of Los Angeles returned more than $82 million.
- The Los Angeles County Development Authority returned nearly $38 million.
- $609.7 million was allocated by the Los Angeles County Homeless Initiative for the fiscal year 2023–24, the largest investment yet to address homelessness.
- Last year's allocation was $547.8 million.
- The funds allocated to the prevention and alleviation of homelessness increased by 11 percent.[6]

## COVID-19 Impact

The loss of jobs and income due to COVID-19, resulting in the forfeiture of housing, will impact the number of homeless for years to come. According to a recent study:[7]

- Homeless with COVID-19 infection experienced a 2.35 times higher age-adjusted mortality risk.
- People between the ages of 35 and 44 were 3.65 times more likely to die from COVID-19.
- In Los Angeles County, 256 homeless people died of COVID-related causes (January 2020–November 2021).

## Food Insecurity

The lack of access to nutritious food results in diet-related health conditions, including hunger and malnutrition, increasing the risk of chronic conditions, such as high blood pressure, high cholesterol, diabetes, and obesity.[8]

- There are 16 corner stores in the 0.4 square mile radius that is Skid Row and no full-service grocers.
- In a survey conducted in Skid Row, 80 percent have said they skipped a meal due to lack of resources, and 27 percent said they did so often.
- 62 percent of homeless had at least one diet-related health condition.
- They are also 2.5 times more likely to be obese as a result of poor nutrition.
- 49 percent of those surveyed have experienced discrimination while obtaining food.
- 31 percent of people have been refused services because they were assumed to be homeless.

## Anti-Camping Laws

Los Angeles Municipal Code Section 41.18 is a city ordinance that prohibits sleeping or camping in certain public spaces, including streets, sidewalks, and parks.[9]

- Los Angeles Municipal Code Section 41.18 is used to criminalize homelessness and punish  individuals for sleeping in public places.
- The ordinance pushes people experiencing homelessness into more dangerous and hidden areas, making it harder for outreach workers and service providers to locate and assist them.

## Homeless Women

Homeless women in Los Angeles require specialized care and support to address their unique needs and challenges.[10]

- Women make up approximately 32 percent of the homeless population in Los Angeles County.
- Women experiencing homelessness are disproportionately Black and between the ages of 51 and 60.[11]
- 83 percent of all women experiencing homelessness in the City of Los Angeles reported that they were living alone.

- In 2019, nearly 56 percent of adult women experiencing homelessness in the City of Los Angeles reported also having experienced domestic violence, with 8 percent of unsheltered adult women reporting that fleeing domestic abuse was the reason for their housing instability.
- Women who experience intimate partner violence suffer higher levels of depression and anxiety than those who do not, resulting in an increased need for mental health treatment.
- Homeless women are 2.9 times more likely to have a preterm delivery, 6.9 times more likely to give birth to an underweight infant, and 3.3 times more likely to have a small-for-gestational-age newborn.[12]
- 73 percent of homeless individuals reported having at least one unmet medical need, and women have an additional set of health care concerns as a result of pregnancy and menstrual cycles.
- The average woman will spend up to $300 annually on feminine hygiene products, an amount well out of reach for women experiencing homelessness.

## LGBTQ+ Youth

Homeless LGBTQ+ youth face unique challenges and dangers that require specialized services and assistance if we are to address their needs in a meaningful and impactful way.

- LA County's young people who are homeless are more likely to be Black, Latino, and/or LGBTQ+.
- High rates of family rejection, discrimination, and violence contribute to the significant number of transgender and other LGBQ+-identified youth who experience homelessness in the United States, with estimates suggesting that they make up 20–40 percent of 1.6 million homeless youth.[13]
- There were 4,775 youth experiencing homelessness, including transition-aged youth (18–24) and unaccompanied minors. 1 in 5 identified as gay, lesbian, bisexual, or sexual orientation nonconforming (2020 LAHSA).[14]

- One in five transgender individuals has experienced homeless-ness at some point in their lives. Nonbinary, questioning, and transgender people make up 3 percent of Los Angeles County's homeless population.[15]
- LA County's young homeless population is more likely to be Black, Latino, and/or LGBTQ+ and lack employment, support systems, or positive adult relationships. Without these support systems, they face an increased risk of substance abuse, mental health issues, and physical health concerns.[16]

## Disability and Homelessness

- 5,916 (about 10 percent) of homeless in LA County have a develop-mental disability (2022 LAHSA).[17]
- In Los Angeles County, a study showed 89 percent of the older home-less population had physical disabilities.[18]
- 12,111 (21 percent) of homeless in LA County reported having a physical disability (2022 LAHSA).
- Older homeless adults suffer from multiple physical disabilities.
- Older adults who are homeless face a disproportionate rate of physi-cal disabilities that are more severe than those experienced by housed older adults.
- The high cost of medical treatment depletes personal savings and assets for many and further exacerbates the cycle of homelessness.

# NOTES

## LA COUNTY FACTS AT A GLANCE

1       LAHSA, *6533—Cvrtm Summary by Geography*, August 19, 2022, https://www.lahsa.org/documents?id=6533-cvrtm-summary-by-geography.

2       Ananya Roy and and Chloe Rosenstock, *We Do Not Forget: Stolen Lives of LA's Unhoused During the COVID-19 Pandemic*, 2021, https://escholarship.org/uc/item/9104j943.

3       Los Angeles Homeless Services Authority, "2020 Greater Los Angeles Homeless Count Results," June 12, 2020, https://www.lahsa.org/news?article=726-2020-greater-los-angeles-homeless-count-results. UCLA, "Study Confirms Serious Health Problems, High Trauma Rates among Unsheltered People in U.S.," October 7, 2019, https://newsroom.ucla.edu/releases/serious-health-conditions-trauma- unsheltered-homeless?utm_content=&utm_medium=email&utm_name=&utm_source=govdelivery&utm_term=.

4       Barbara Ferrer, Louise Rollin-Alamillo, Alex Ho, Gary Tsai, Emily Vaughn-Henry, Benjamin Henwood, and Stephanie Kwack, *Mortality Rates and Causes of Death among People Experiencing Homelessness in Los Angeles County*, May 2023, http://publichealth.lacounty.gov/chie/reports/Homeless_Mortality_Report_2023.pdf.

5       Connor Sheets, *Los Angeles Agencies Returned $150 Million in Federal Funds to House Homeless People*, Los Angeles Times, September 24, 2022, https://www.latimes.com/california/story/2022-09-24/los-angeles-agencies-returned-150-million-in-federal-funds-to-house-homeless-people.

6        County of Los Angeles Homeless Initiative, *FY 2023–24 Approved Budget—Homeless Initiative*, 2023, https://homeless.lacounty.gov/fy-2023-24-budget/.

7        N. A. C. Porter, H. K. Brosnan, A. H. Chang, B. F. Henwood, and R. Kuhn, "Race and Ethnicity and Sex Variation in COVID-19 Mortality Risks among Adults Experiencing Homelessness in Los Angeles County, California," *JAMA Network Open* 5, no. 12 (2022): e2245263, https://doi.org/10.1001/jamanetworkopen.2022.45263.

8        Los Angeles Community Action Network (LA CAN), *The Paradox of Food in Skid Row (2017 Community Food Assessment)*, 2017, https://cangress.org/publications/.

9        "Sec. 41.18. Sitting, Lying, or Sleeping or Storing, Using, Maintaining, or Placing Personal Property in the Public Right-of-Way," American Legal Publishing Corporation, https://codelibrary.amlegal.com/codes/los_angeles/latest/lamc/0-0-0-128514.

10       LAHSA, *6515—Lacounty Hc22 Data Summary*, September 8, 2022, https://www.lahsa.org/documents?id=6515-lacounty-hc22-data-summary.

11       Neighborhood Data for Social Change, *Women Experiencing Homelessness in Los Angeles*, March 2020, https://la.myneighborhooddata.org/2020/03/women-experiencing-homelessness- in-los-angeles/.

12       The American College of Obstetricians and Gynecologists, *Health Care for Homeless Women*, October 2013, https://www.acog.org/clinical/clinical-guidance/committee-opinion/articles/2013/10/health-care-for-homeless-women?utm_source=redirect&utm_medium=web&utm_campaign=otn.

13       National Center for Transgender Equality, "Housing & Homelessness," 2019, https://transequality.org/issues/housing-homelessness.

14      LAHSA, "LAHSA Provides 2020 Update on Youth Homelessness," June 3, 2021, https://www.lahsa.org/news?article=750-lahsa-provides-2020-update-on-youth-homelessness.

15      Ethan Ward, "Many Young Unhoused LGBTQ+ People Are Living on the Streets. Often, Their Families Put Them There." *LAist*, November 8, 2021, https://laist.com/news/housing-homelessness/young-unhoused-homeless-lgbtq-people-living-streets-families-la-homelessness.

16      United States Interagency Council on Homelessness, *Homelessness in America: Focus on Chronic Homelessness among People with Disabilities*, 2018, https://www.usich.gov/resources/uploads/asset_library/Homelessness-in-America-Focus-on-chronic.pdf.

17      LAHSA, *6505 - COC Hc2022 Data Summary*, September 7, 2022, https:// www.lahsa.org/documents?id=6505-coc-hc2022-data-summary.

18      Victoria Vantal, "Physical Disabilities Lead to Hopelessness on the Streets," *Invisible People*, March 10, 2020, https://invisiblepeople.tv/physical-disabilities-lead-to-hopelessness-on-the-streets/.